photographing
Indian Country

Where to Find Perfect Shots and How to Take Them

Gordon and
Cathie Sullivan

THE COUNTRYMAN PRESS
WOODSTOCK, VERMONT

Maps by Paul Woodward, © The Countryman Press
Book design and composition by S. E. Livingston

Photographing Indian Country
978-0-88150-966-3

Published by The Countryman Press,
P.O. Box 748, Woodstock, VT 05091

Distributed by W. W. Norton & Company, Inc.,
500 Fifth Avenue, New York, NY 10110

Printed in the United States of America

10 9 8 7 6 5 4 3 2 1

*Title Page: Many of the ruins at Hovenweep are
located on the rim above a steep ravine, which
makes for some wonderful light for early-morning
and late-afternoon shots. Hovenweep Castle is best
photographed using a strong foreground. Try
alternating horizontal and vertical shots.
Right: With advancements in agriculture, cliff
dwellings began to play a prominent role in life
among the Southwest's first peoples. Square Tower
House, Mesa Verde National Park.*

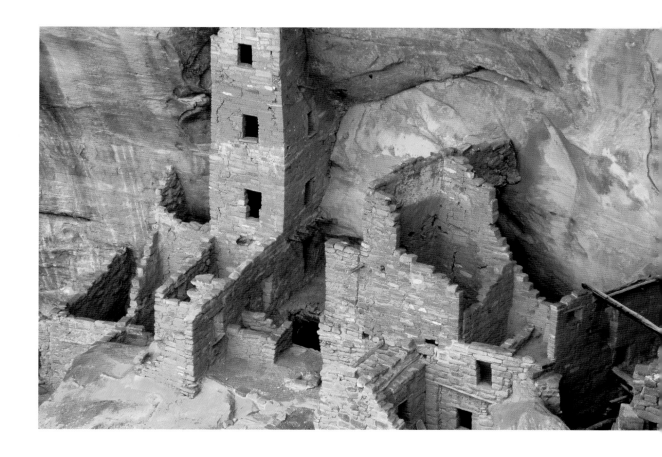

*We dedicate this book to Native American people everywhere who adhere to
the wonderful traditions of their ancestry. Without this connection and stewardship
our human history would suffer greatly indeed.*

No book of any magnitude is ever completed by a single set of hands or a solitary vision. We owe thanks to the administrative leadership of Kermit Hummel at Countryman Press and the dedicated editorial board at W. W. Norton, without whom the idea for *Photographing Indian Country* would never have germinated. However, a special thanks goes out to everyone who played a part in seeing the project to a bountiful end. To professionals like Lisa Sacks, Caitlin Martin, Melissa Dobson, Paul Woodward, Susan Livingston, and Fred Lee, who worked on the manuscript, design, illustrations, and printing, and in the end created this fitting tribute to Indian country and the ancient peoples who once lived on this land.

—Gordon & Cathie Sullivan

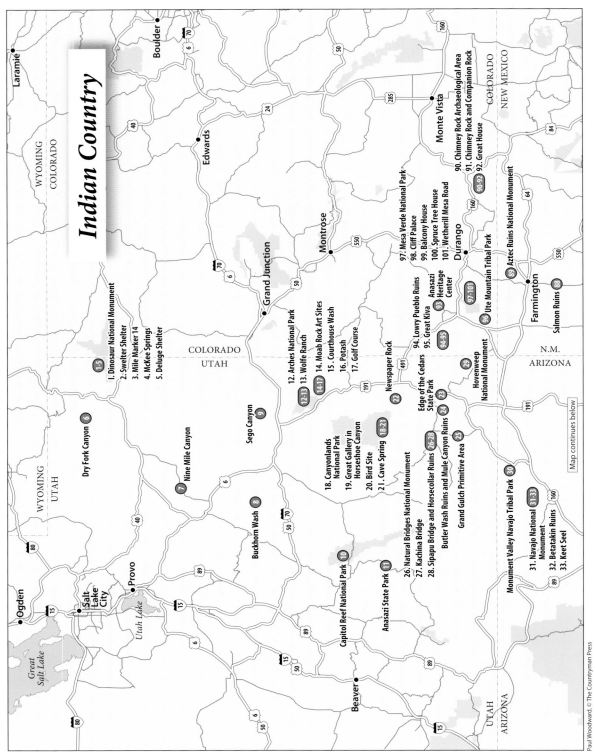

Indian Country

1. Dinosaur National Monument
2. Swelter Shelter
3. Mile Marker 14
4. McKee Springs
5. Deluge Shelter
6. Dry Fork Canyon
7. Nine Mile Canyon
8. Buckhorn Wash
9. Sego Canyon
10. Capitol Reef National Park
11. Anasazi State Park
12. Arches National Park
13. Wolfe Ranch
14. Moab Rock Art Sites
15. Courthouse Wash
16. Potash
17. Golf Course
18. Canyonlands National Park
19. Great Gallery in Horseshoe Canyon
20. Bird Site
21. Cave Spring
22. Newspaper Rock
23. Edge of the Cedars State Park
24. Butler Wash Ruins and Mule Canyon Ruins
25. Grand Gulch Primitive Area
26. Natural Bridges National Monument
27. Kachina Bridge
28. Sipapu Bridge and Horsecollar Ruins
29. Hovenweep National Monument
30. Monument Valley Navajo Tribal Park
31. Navajo National Monument
32. Betatakin Ruins
33. Keet Seel
88. Salmon Ruins
89. Aztec Ruins National Monument
90. Chimney Rock Archaeological Area
91. Chimney Rock and Companion Rock
92. Great House
93. Anasazi Heritage Center
94. Lowry Pueblo Ruins
95. Great Kiva
96. Ute Mountain Tribal Park
97. Mesa Verde National Park
98. Cliff Palace
99. Balcony House
100. Spruce Tree House
101. Wetherill Mesa Road

Map continues below

Paul Woodward, © The Countryman Press

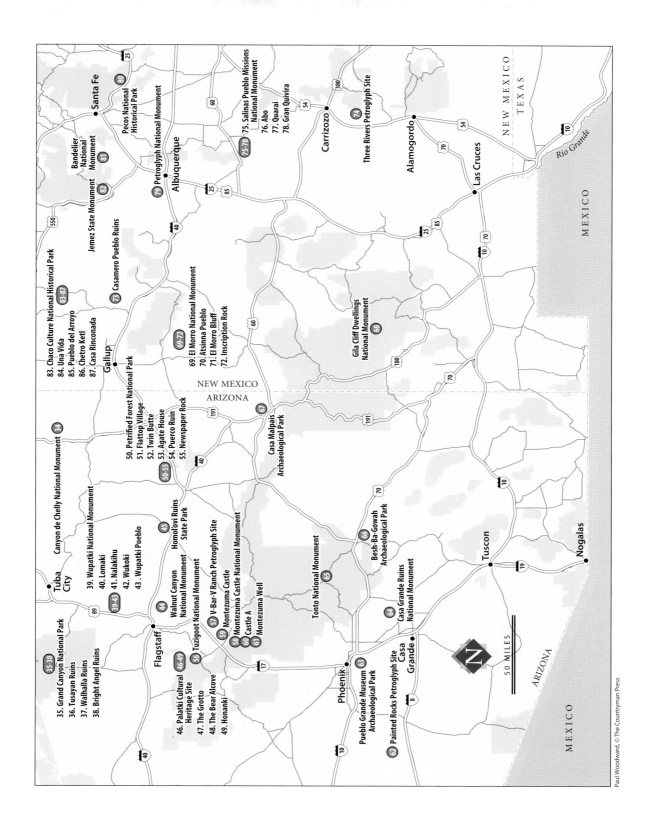

35. Grand Canyon National Park
36. Tusayan Ruins
37. Walhalla Ruins
38. Bright Angel Ruins

39. Wupatki National Monument
40. Lomaki
41. Nalakihu
42. Wukoki
43. Wupatki Pueblo

46. Palatki Cultural Heritage Site
47. The Grotto
48. The Bear Alcove
49. Honanki

50. Petrified Forest National Park
51. Flattop Village
52. Twin Butte
53. Agate House
54. Puerco Ruin
55. Newspaper Rock

Canyon de Chelly National Monument

Homolovi Ruins State Park

Walnut Canyon National Monument

Tuzigoot National Monument

V-Bar-V Ranch Petroglyph Site

Montezuma Castle

Castle A

Montezuma Castle National Monument

Montezuma Well

Tonto National Monument

Besh-Ba-Gowah Archaeological Park

Casa Grande Ruins National Monument

Pueblo Grande Museum Archaeological Park

Painted Rocks Petroglyph Site

Casa Grande

Flagstaff

Tuba City

Phoenix

Tuscon

Nogalas

NEW MEXICO
ARIZONA

MEXICO

ARIZONA

50 MILES

Casa Malpais Archaeological Park

Gila Cliff Dwellings National Monument

Gallup

83. Chaco Culture National Historical Park
84. Una Vida
85. Pueblo del Arroyo
86. Chetro Ketl
87. Casa Rinconada

Casamero Pueblo Ruins

Jemez State Monument

Bandelier National Monument

Pecos National Historical Park

Santa Fe

Petroglyph National Monument

Albuquerque

69. El Morro National Monument
70. Atsinna Pueblo
71. El Morro Bluff
72. Inscription Rock

75. Salinas Pueblo Missions National Monument
76. Abo
77. Quarai
78. Gran Quivira

Three Rivers Petroglyph Site

Carrizozo

Alamogordo

Las Cruces

NEW MEXICO
TEXAS

MEXICO

TEXAS

Rio Grande

Paul Woodward, © The Countryman Press

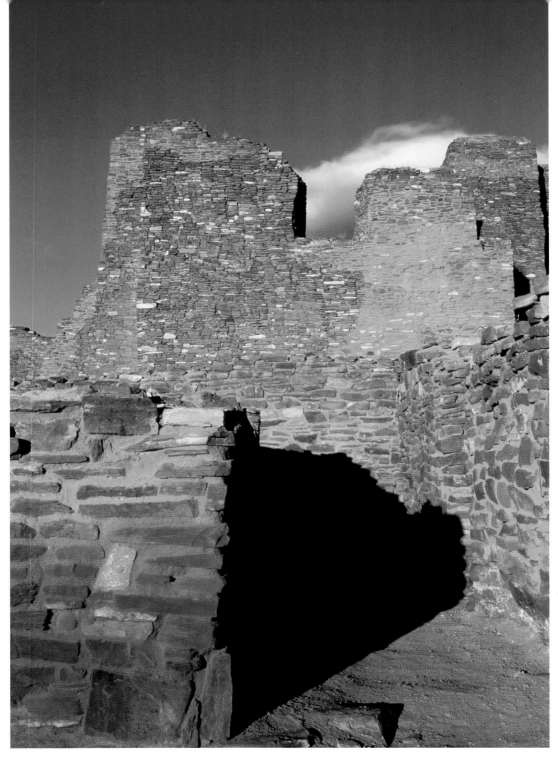

At Salinas Pueblo Missions Monument in the Estancia Basin, photographers will find three very different mission churches complementing an awe-inspiring natural environment. This image is of Quarai Ruins.

Contents

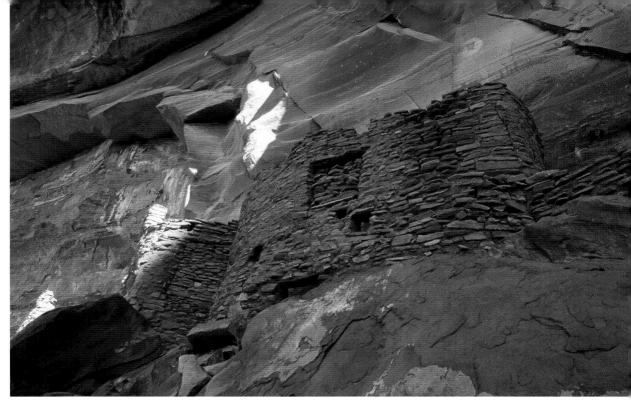

There are a number of ruins and rock-art sites housed within Palatki Cultural Heritage Site and Honanki Ruins. Our favorite is the Grotto, which is built amid rose-colored sandstone. The Grotto is best photographed in open shade to maximize contrast.

Introduction

Shaped by the relentless work of wind, water, and heat, the rugged geography of the American Southwest surely ranks among the most impressive on earth. Here is a vast, challenging, and sometimes fierce landscape held in the tight grip of change. A place where sand shifts on the slightest breeze, and towering canyon walls, colorful as a painter's palette, ascend above the desert floor, gradually wearing away in time. Those same canyon walls hold evidence of oceans that once flooded the land, layer after layer of sediment originating as runoff from mountains that are no longer there.

These age-hardened layers are colored sunset crimson, honey gold, beige, and russet, occasionally white as new snow or dark as sable. Each represents a new chapter in the earth's creation story staged over billions of years. And there is another story, a human story, beginning about twelve thousand years ago, the blink of an eye in geologic time. This story is about the first people who occupied the arid Southwest. It is a saga chiseled and painted on sandstone walls or more vividly portrayed in the ruins of countless dwellings today abandoned and silently awaiting the photographer's eye.

Canyon de Chelly National Monument is a perfect place to photograph ancient dwellings. A short trail descends the canyon and ends at White House Ruins.

Our goal in *Photographing Indian Country* is to enhance your Southwest adventure as you bring your photographer's eye to some of the most remarkable places on earth. On the pages that follow we will introduce you to an ancient race of people and explore the interesting legends and artifacts they left behind.

I traveled to the Southwest originally as a photographer over four decades ago. I was a youngster in the field of landscape imagery, albeit filled with ambition and anticipation. At first I assumed a few quick trips from my home in Montana's Rocky Mountains would fill the desert niche in my photography portfolio. I packed a pair of 35mm cameras, a sturdy tripod, a pile of empty journals, and fifty rolls of film. I drove south for a couple of days and watched with amazement as the massive Rocky Mountains, the backbone of the continent, gradually flattened into desert somewhere in southern Utah. Suddenly the terrain was tabletop-flat and dry as old bone.

I was blown away by the visual splendor of Indian Country from the beginning, but excited beyond belief once I learned the poignant human story that resides in this rugged landscape. As a photographer, I was initially challenged by the harsh desert light, long afternoon shadows, and intense heat, but intrigued by the immense, untouched openness stretching like an empty canvas across distant horizons. It took years for me to finally feel comfortable photographing Indian Country—years to create successful images and slow down enough to truly comprehend the ancient story whispered on the desert wind.

After meeting Cathie, my wife, photographing the Southwest suddenly got easier. I had a partner who understood the tremendous influence humans have on a natural landscape. Cathie is a professional portrait photographer with decades of experience watching people through the lens of a camera. From the outset, she sensed the region's powerful legacy. It wasn't long before the magnificent landscape and the human saga coalesced in our work, resulting in our award-winning *Roadside Guide to Indian Ruins & Rock Art of the Southwest,* published in 2004.

Throughout our professional lives we have relied on cameras ranging from 35mm single-lens reflex to medium-format and large-format 4x5s equipped with incredible Linhof lenses. Today, we shoot digital Canons and Nikons, appreciating that what happens in front of the camera—the beauty, the intrigue, and the story—remains the same even when examined through different lenses.

Over the years, Cathie and I have matured as photographers. At the same time, we developed a love for Indian Country, following from our desire to comprehend the meaning of those who came before. In essence, their story is now our story. It tells of times of struggle, times of plenty, and times of change.

Our experience in Indian Country has taught us something very special about ourselves as artists and photographers. We have found that though the final images are important, in the end, it is the very experience of taking pictures, the pursuit of artistic creation in fully engaging with these magnificent sites, that is most meaningful and rewarding. We hope to pass our appreciation for this wonderful landscape and its prehistoric treasures on to you as we explore Indian Country together.

Those Who Came Before

We don't know exactly when the first humans arrived in the American Southwest. But we know with some certainty from where they came and the route they traveled.

Thousands of miles north, on the western coast of Alaska, the continent of North America and Asia are separated by less than 60 miles of shallow sea. The place is the Bering Strait,

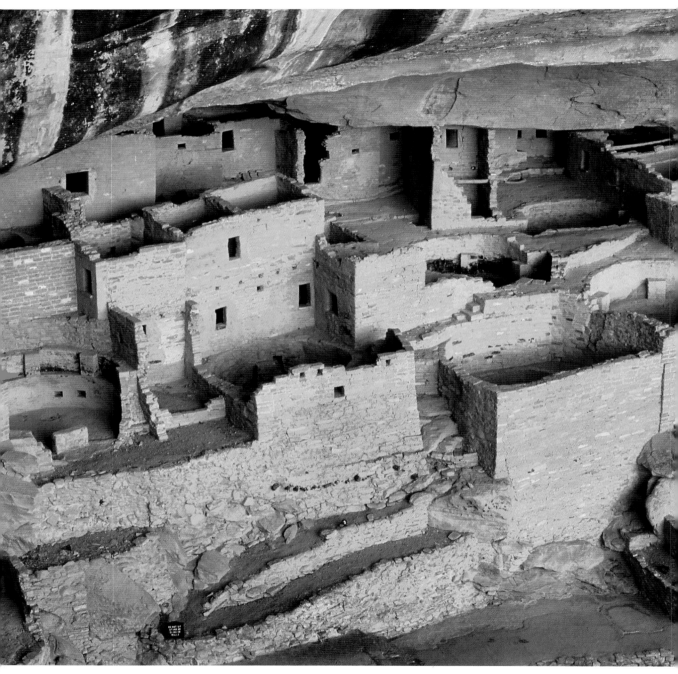

Some of the best maintained cliff-dwelling ruins in the Southwest are found at Colorado's Mesa Verde National Park. Here, Cliff Palace awaits the photographer's creative eye.

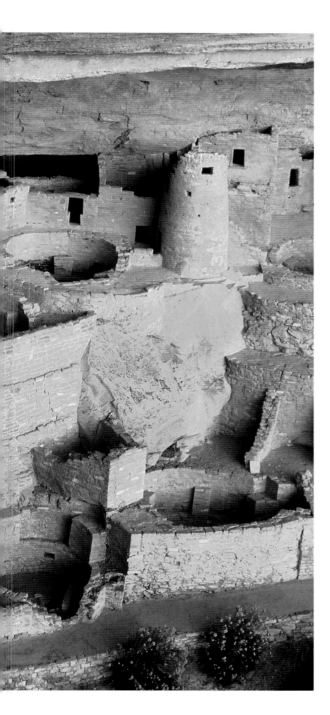

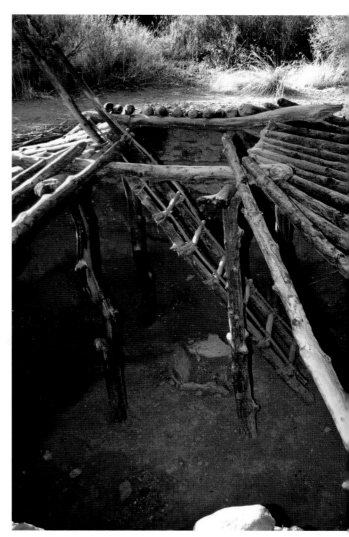

Some of the very first inhabitants of the Southwest lived in modest pit houses excavated in the dry earth. Beams for the subterranean homes were usually gathered locally. The rudimentary dwelling pictured here is at Utah's Anasazi State Park.

where Siberia and Alaska face each other, with the Diomede Islands scattered between them. During the last Ice Age much of the earth's water was in the form of icepack and glaciers, causing sea levels to fall and leaving places like the Bering Strait dry, thus capable of being used as land bridges.

Animal migration between continents increased, with herds being pursued by Mongoloid hunters. Scientists believe it was these wandering hunters traveling south along ice-free corridors who eventually populated the Great Plains, the Southwest, and as far south as Central America. Other clans pressed eastward, ultimately finding their way to the southern tip of Florida.

Human migration across the Southwest probably took place in several waves prompted by constantly changing climate and the availability of grass for grazing animals. The Clovis hunters were the first to arrive, then the Folsom and Cody cultures, names derived from the types of tools used in hunting. As the herds continued their relentless search for grass, hunters briskly followed, leaving only vague traces of human occupation. As they wandered, the ancient ones lived in subterranean pit houses.

Around 5000 B.C. many large species abruptly dwindled and human life changed dramatically. Through the millennia that followed people became more settled, forced to rely more on vegetation while wild species slowly rebounded. Clusters of pit houses started to appear, making it possible for modern archaeologists to study human life and movement through the untamed land.

Perhaps the most significant change came as a result of a gift from kin who settled as far south as Mesoamerica. The bequest was corn, or maize, a plant that evolved naturally from teosinte, a wild grass featuring miniature cobs and growing abundantly throughout central Mexico. Over some fifteen hundred years, Mesoamericans domesticated corn, cross-pollinating various strains to arrive at the kind of corn crop we recognize now. By A.D. 500 cultivation of the crop had been introduced to northern cultures, where corn became a staple of life. Agriculture gradually replaced hunting and gathering, and settlement in larger villages followed.

As reliance on agriculture grew, pueblo dwellings made of stone, some rising as high as three stories, replaced pit houses. More efficient farming allowed for leisure time and the advancement of arts and crafts like pottery, basketry, and weaving.

Why farmers eventually moved from their homes adjacent to fields to more secure cliff dwellings located high in the canyon walls remains a mystery. Some of the most spectacular images in Indian Country feature these cliff dwellings.

As a testament to prehistoric advancement, a remarkable gallery of etched petroglyphs and painted pictographs was left by ancient artisans throughout the region known today as the Four Corners, which includes parts of Colorado, New Mexico, Arizona, and Utah.

Joining the rock art are ruins, the remains of homes and villages speaking to the advancement of prehistoric life. Both the ruins and the rock art document a period extending well before the birth of Christ and continuing through the arrival of Christian missionaries who worked to convert many of the region's Native peoples.

The Anasazi, the Mogollon, the Hohokam, the Fremont, the Sinagua, and the Salado are among the prehistoric peoples who left their mark on the Southwest. The differences among them are both subtle and substantial, issuing from the geographic space they occupied and their various culinary, religious, artistic, and other cultural practices.

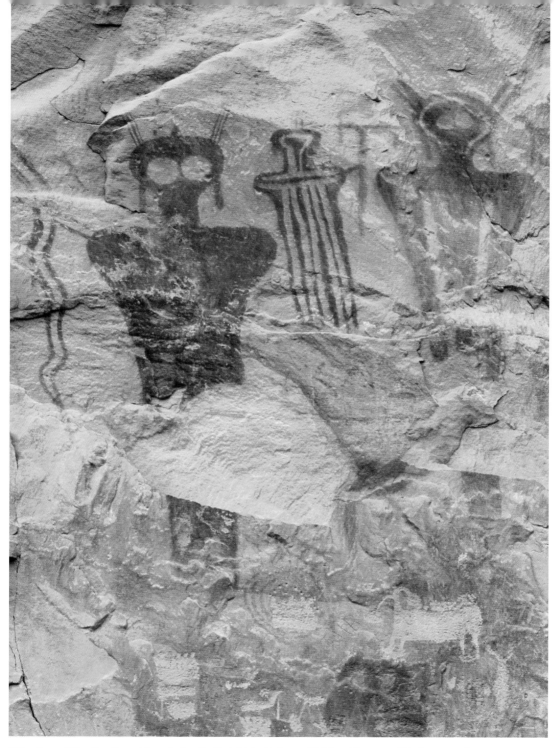

The story of the Southwest is only partially told in its beautiful landforms, wild rivers, and vast open spaces. The ancient rock art appearing on sandstone walls throughout the region gives us insight into life among the ancient ones.

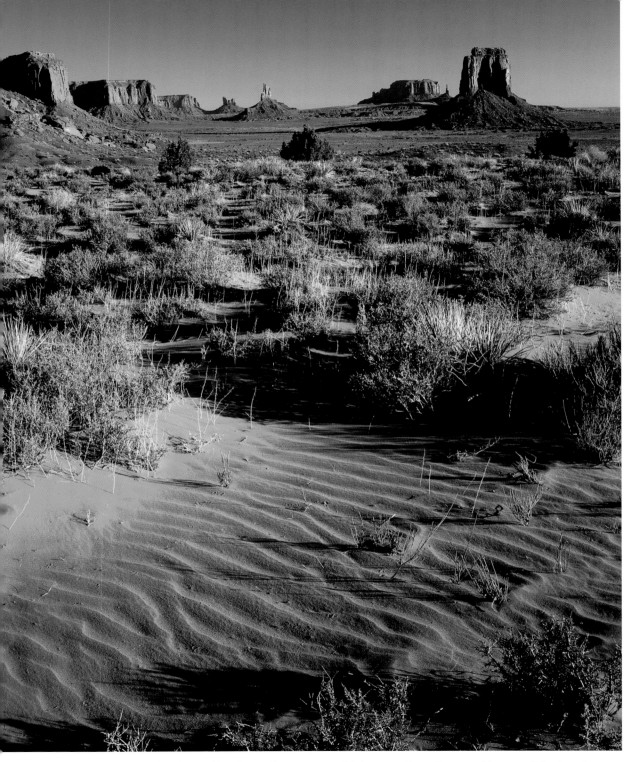

Monument Valley, located in the northeast corner of Arizona, reflects the rugged beauty of the American Southwest. Sand in the region is constantly shifting, moved by the slightest breeze.

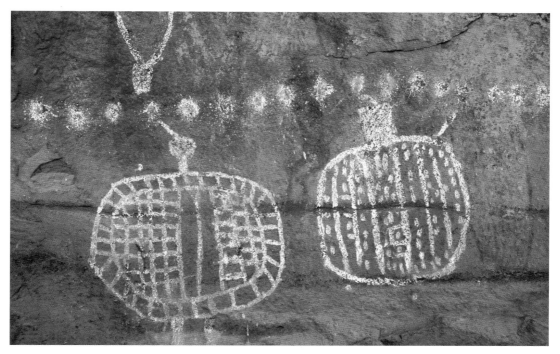

Pictographs like those found in Canyonland's Peekaboo Canyon were painted on sandstone surfaces employing a number of techniques including handpainting and the use of crude brushes. One of the most interesting techniques required blowing paint through small reeds.

How to Use This Book

I was mesmerized one morning in a remote arroyo in Utah's Canyonlands National Park as dawn washed a coppery tint across Navajo sandstone. When the spectacle was over, I turned to leave and was surprised by a group of small pictographs painted on a ledge behind me. Someone else, ages before, had been drawn to this quiet desert place. To record the event they had left their mark.

Throughout our time photographing the rock art and ruins of Indian Country, Cathie and I have discovered a number of hidden storyboards and still wonder about their meaning. We have found petroglyphs in backcountry places and walked alone among solitary ruins protected inside secluded canyons. Fortunately most of the sites we will visit in *Photographing Indian Country* are located directly on or adjacent to major highways, so getting to them is not difficult. Knowing the best time to be there and how to make the most of your photographic outing will, however, take a little more effort.

For convenience our book is organized by state, and accompanying each site are directions from major highways or short access roads. We also include a schedule of when the sites are open and any special gear that might

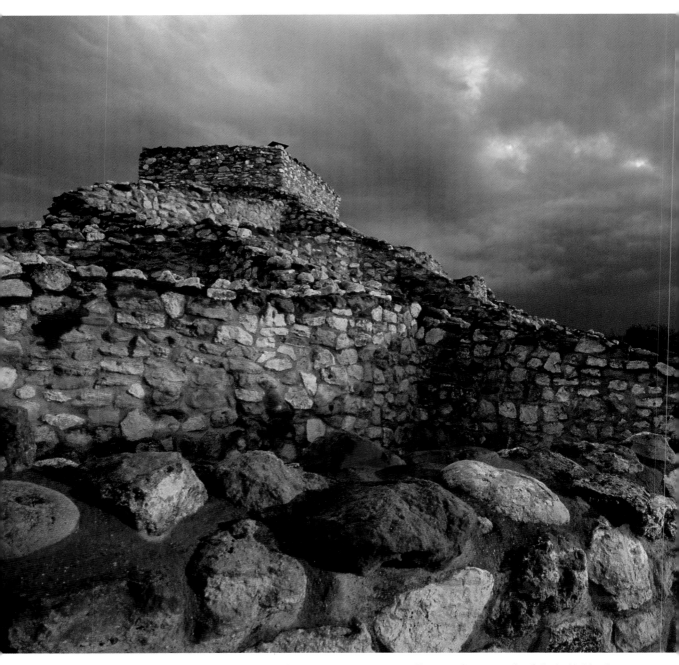

The beautiful ruins at Tuzigoot National Monument in Arizona offer a perfect example of the individual nature of pueblo structures built by distinctive Native peoples. In this case, the rooms are staggered. The better the photographer understands those who once occupied these sites, the more robust the human story becomes.

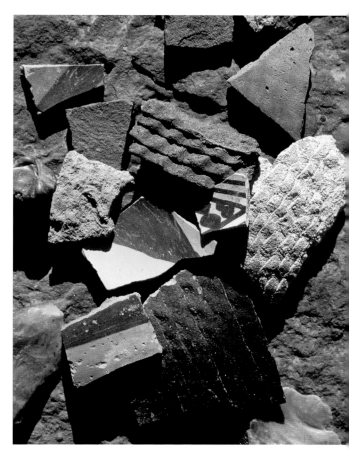

A chief task of the photographer is to tell an interesting story complete with the small details that help us understand how life was actually lived in days long past. Pottery shards are all that is left in some cases to portray the considerable effort and craft put into pots, jars, and vessels.

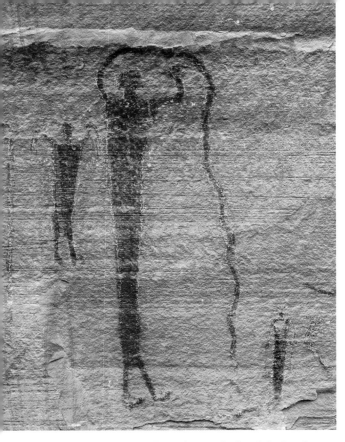

The pictographs and petroglyphs of the Southwest tell the tale of the ancient ones, just as our photographs tell stories and teach lessons today.

ciation of the region and the sites we visit. The better we understood the people who occupied the sites or left art for us to explore, the more creative we were and the stronger the photographic story became. It wasn't long before the cab of our truck was filled with books, brochures, and handouts, which we studied religiously. We also kept a journal, which included notes on places we wanted to revisit during another season or at a different time of day, and any distinctive features that might help us sort and title our images after processing.

Our book emphasizes human history and presence in the photographing of Indian Country. As you travel with camera in hand, one of the first things you will notice is just how well primitive ruins and rock art fit within their surroundings. To enhance the human story that unfolds within this vast landscape, we encourage you throughout to take note of smaller photographic subjects like tools, clothing, native plants, pottery shards, and other museum pieces and artifacts.

Photographing Indian Country is the kind of book we would have liked to have had when we began photographing in the Southwest—a book that not only provides solid information about place but deals with practical and technical issues specific to photographic equipment, approaches, and technique. We expect that this guide will give you the background necessary to make your time in the field more meaningful and productive.

The old saying "a picture is worth a thousand words" definitely applies to *Photographing Indian Country,* so pay close attention to the compositional content of the images supplementing the text, as well as information we provide on the technical approaches that make them work. There is much to be learned from simply viewing an image critically and identifying the components that make it successful.

help you make the most of your visit. Contact information such as Web addresses and telephone numbers is also provided.

Not surprising in a book of this kind, the most valuable advice we offer here concerns approaching each site photographically, including what time of day works best, what equipment to lug along, and how different exposures might be made. The next section is devoted exclusively to photography, with additional information provided in each site description.

One thing Cathie and I have discovered during our photographic travels is the importance of having a cultural and historical appre-

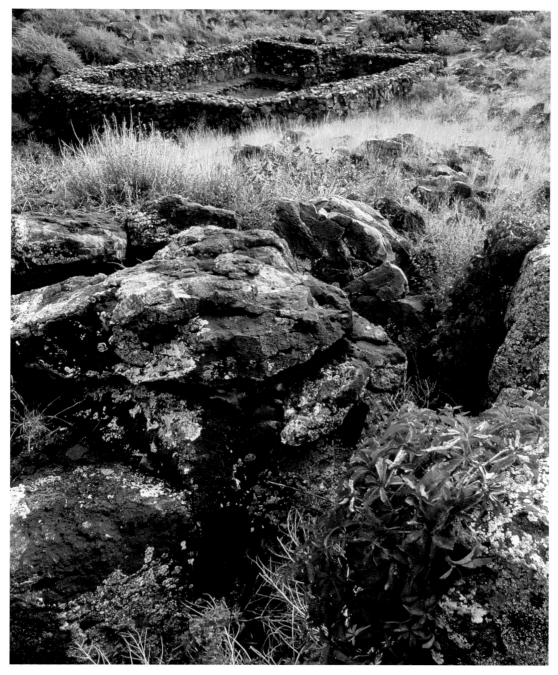

Pueblos at Casa Malpais, in Arizona, were constructed from dark volcanic stone and eventually surrounded by native vegetation. The site vividly demonstrates how well ancient dwellings fit within their surroundings.

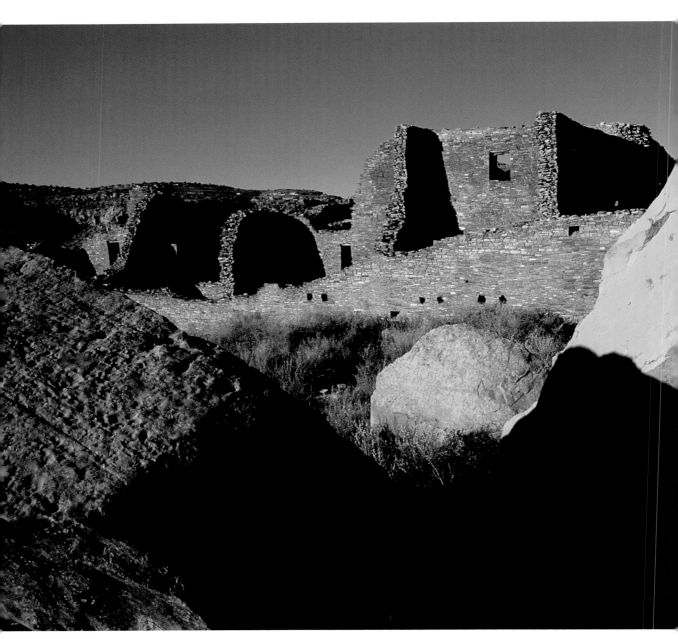

November, when the summer crowds are gone, can be a great time to visit Chaco Canyon. When planning a trip to photograph Southwest ruins and rock art, consider visiting during months when tourism wanes.

How We Photograph Indian Country: Special Considerations, Equipment, Composition

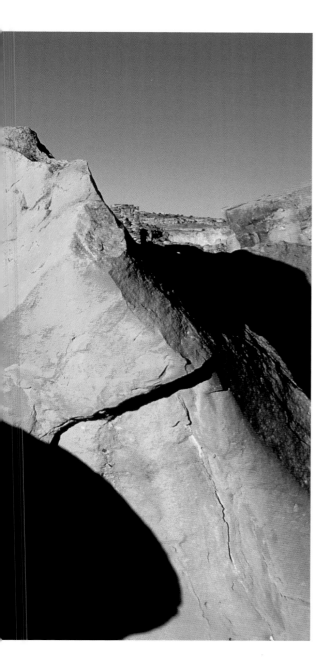

Special Considerations

It was mid-November when Cathie and I first drove the unpaved road leading to Chaco Canyon. After reading about it we were excited to experience that remote corner of New Mexico. No amount of reading, however, can prepare you for the majesty and mystery of Chaco Canyon. It was early evening when we arrived to a tangerine sunset dissolving slowly over the western horizon. We were surprised to find that we were alone; not another trailer in the campground, no sound of other cars or human voices to interrupt the stillness. The silence was remarkable, given that, as the center of Anasazi life, Chaco Canyon once bustled with activity and housed thousands of people. For the next few days we explored the canyon's cryptic ruins, carrying cameras on tripods. It was as if we were the first to discover this mysterious place abandoned in the desert.

It doesn't take long to recognize, when shooting in the Southwest at a place like Chaco Canyon, that the harsh afternoon light and low-angle shadows can be a hindrance to quality images. This is compounded by the fact that many Indian Country ruins are of light-colored sandstone, which in direct light lacks texture and detail. We found it best to shoot between dawn and around ten o'clock and evenings between five o'clock and the final glimmer of sunlight. Since many of the area's national monuments and parks close around 5 PM and re-open at 8 or 9 AM, try to plan on being the first through the gate or the last to leave at night.

Another thing to consider is the amount of time spent at a site. Schedule your outings

carefully so that you are able to set up your shots sufficiently. It takes some planning to be at a location at a time of day when you will be able to best capture the significance and mood of each site. Don't let time constraints force you to shoot in unsatisfactory light. Give yourself plenty of time to work on the images you have in mind, and don't cut things short just to get to the next place down the road.

The morning after the tangerine sunset over Chaco Canyon, Cathie and I began our work by getting accustomed to the way the light moved across the ruins and surrounding landscape. By the end of the day we knew what sites would be best photographed in the morning and what locations should wait for evening light. Three days later, we left Chaco Canyon with a collection of solid images created in just the right light.

As you photograph Indian Country, don't try to cram too much in. Planning carefully and waiting for the right light can mean the difference between exceptional images and merely commonplace ones. The ruins at Chaco Canyon, like those found throughout the Four Corners region, can appear nondescript under the wrong light but are explosively powerful when photographed under the right conditions.

Protecting Ruins and Rock Art

Soon after their discovery, which came about with the settlement of the West, ancient arti-

There are those photographers who mistakenly believe that if you have a thousand sunsets you probably have enough. Cathie and I think otherwise. We are hooked on sunset and sunrise shots and welcome pleasant surprises like the one over Turret Arch in Arches National Park. Nothing could be finer!

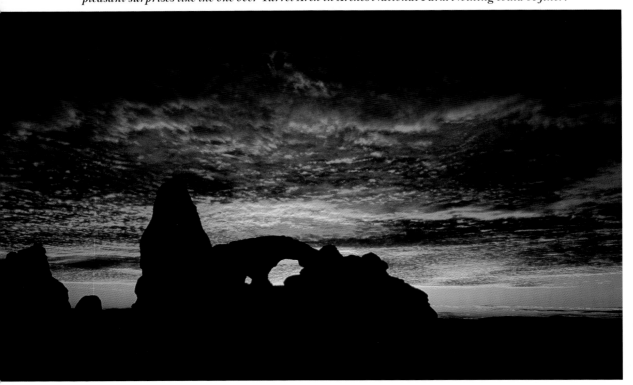

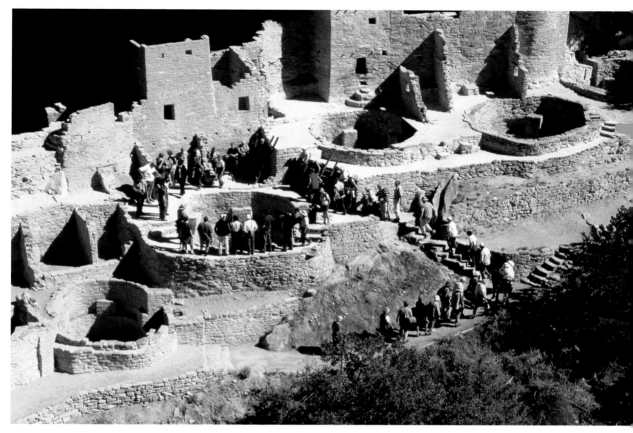

Of the 4,000 archaeological sites housed at Mesa Verde National Park, 600 are ancient cliff dwellings of great interest to the photographer. For best results, arrive at Mesa Verde armed with plenty of time and energy, for here is one of the most comprehensive attractions in the Southwest. The park is heavily visited, so time your visit carefully for optimum results.

facts fell under the protection of the federal Antiquities Act, first written into law in 1906. As a result, many famous sites today fall under the jurisdiction of federal agencies like the National Park Service and the Bureau of Land Management, while others are maintained by various state agencies and private stewards. It is of the utmost importance to keep in mind, however, that we *all* share a responsibility to protect and preserve these remarkable sites. The ancient treasures of the Southwest are today under siege by thoughtless vandals, as well as by those who unwittingly threaten these vulnerable areas because they are uninformed.

Be mindful of park guidelines when visiting and photographing ancient sites. When viewing rock art, be sure to respect their fragile nature: *never* touch or walk on rock art, as these surfaces are easily abraded, and oils from the skin can cause irreparable damage. Do not disturb any artifacts you may encounter. In short, leave everything as you found it, and no trace of yourself behind. The photographs you take will be your best memento.

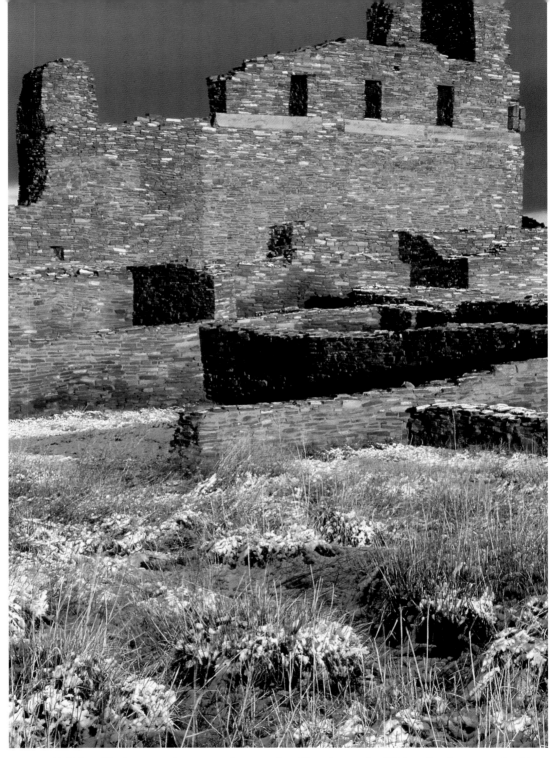

Strong sidelight adds drama and texture to images of pueblo ruins made of light-colored stone, as in this shot of Abo Ruins, Salinas Pueblo Missions National Monument in New Mexico.

Utilizing Light

As photographers, we use light to create images in the same way painters rely on a broad palette of colors to bring to life a masterpiece. Understanding light, and specifically desert light, will help you immensely in photographing Indian Country. So let's talk about the four basic types of natural light and how they come into play in photographing desert ruins and rock art.

Sidelight

Whether you are an accomplished professional photographer or a point-and-shoot enthusiast with some experience, you certainly know the artistic value of early-morning and late-evening light. This light comes from a lower angle and is warmer after being reflected from the earth's surface. The angle not only intensifies colors but causes distinct shadows and heightens contrast. We crave this light in our Southwest images, simply because it adds pleasing texture to sandstone subjects like the adobe walls of ancient ruins. We especially like warm light when it comes from the side, further heightening detail and texture as it creates tiny shadows between specific objects like sandstone blocks, mortar lines, and divisions between adobe walls.

One of the techniques we often employ in our shots is the use of a foreground that leads inward toward the primary subject. For this technique, strong sidelight provides a wonderful pathway in to the subject, even if that subject is not illuminated by the same light. Most ruin walls are flat and require sidelight to impart as much detail and depth as possible, adding visual interest to what might otherwise

The image of Besh-Ba-Gowah Archaeological Park shows the dramatic use of dark shadow to add interest and frame colorful subjects.

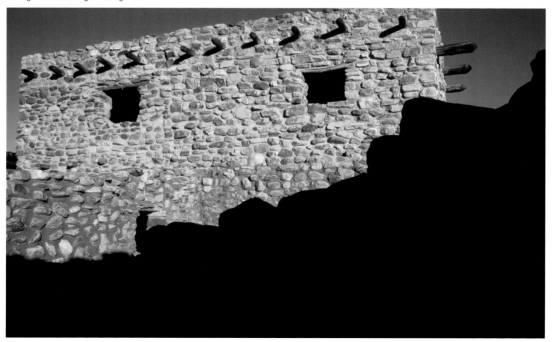

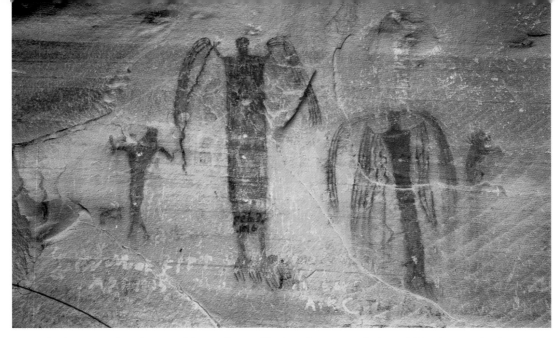

Open shade is great for photographing rock art, allowing the russet coloring of this pictograph, shot at at Buckhorn Wash in Utah, to really stand out.

be a dull image. Sidelight is also capable of creating long, deep shadows. The image of Besh-Ba-Gowah is a good example of using a dark shadow to intensify composition. In this case, dark shadow actually frames the image.

Although the most effective sidelight occurs during the first couple of hours after dawn and the last few hours before dusk, sidelight is present to a lesser degree at other times during the day. In the photograph of late-morning sidelight on Mesa Verde's Cliff Palace, the play of early-afternoon light produces just enough shadow to increase detail without dominating the entire scene.

Sidelight is also a good choice for shooting rock art, again because it heightens contrast. A tip to try on rock art when shooting with sidelight is to include a polarizing filter. Not only will the filter deepen blue skies, it will saturate other colors like russet, red, brown, and orange, all hues characteristic of sandstone.

Cathie and I have continued to use polarizing filters in our digital work, even though some photographers maintain that similar effects can be added during processing. We feel the filter helps us judge the effect right on the spot and our goal is to create the best image we can in the field and minimize processing time at home.

Diffused or Soft Light

Diffused light resulting from overcast skies is more common in the Four Corners region during the fall and winter months. Filtered either through a layer of clouds or existing as natural shade, diffused light lessens shadows while creating a pastel effect in images like sweeping landscapes, midrange close-ups, and cliff dwellings under overhanging ledges.

Shooting in diffused light requires more exposure; given the depth-of-field requirement of most landscapes, we recommend adjusting shutter speed while maintaining smaller aper-

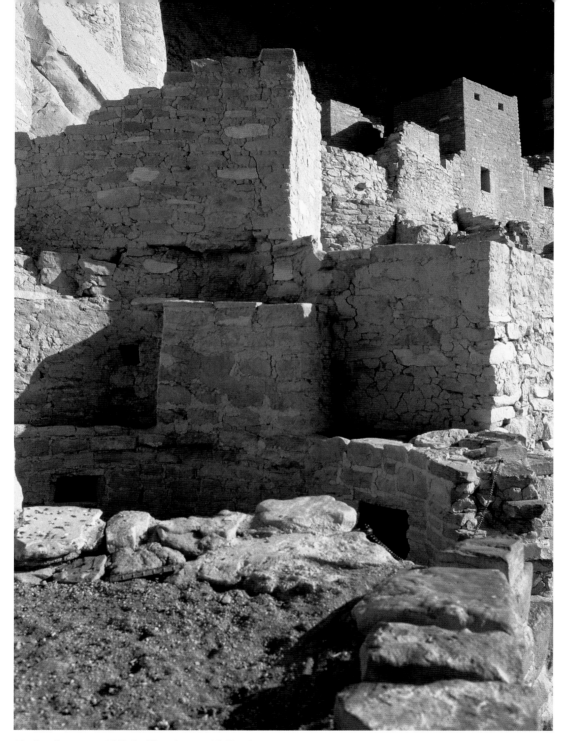

Early-afternoon sidelight illuminates Cliff Palace, Mesa Verde National Park, helping to make the final image painterly. Sensitivity to various levels of sidelight will help as you photograph subjects located in deep canyons.

tures. In these conditions a good tripod is a must. On overcast days in the Southwest you could easily find yourself shooting at f-22 at one-sixth of a second. When photographing in diffused light, we always use a tripod, mirror lockup, and remote release.

Soft or diffused light is great for shooting rock art, because it reduces glare and increases contrast between the bright sandstone and the art. In the case of petroglyphs (chiseled images), the tonal difference comes from the natural patina on sandstone having been chipped away by artisans, exposing virgin rock below. With pictographs (painted images), lessening glare via diffused light allows red and white, common colors in rock art, to stand out. Try a polarizing filter when shooting rock art in diffused light. At full polarization it seems to enhance the entire image. The photograph of a pictograph at Buckhorn Wash, shown here, was taken in open shade, on a tripod with a polarizing filter at full polarization. The shot was at f-22 for good depth of field at a shutter speed of one-fifteenth of a second. Notice how the filter saturates the russet color, causing the art to stand out.

Diffused light can also be used to good effect when shooting inside a ruin, where surrounding light is actually reflected. The image of the arching doors between rooms in Chaco Canyon's Pueblo Bonito is a good example. Notice how the reflected light promotes a sense

Diffused light is a factor inside most ruins. It can be used effectively when contrasted with direct light, as in this shot of the arching doors at Pueblo Bonito.

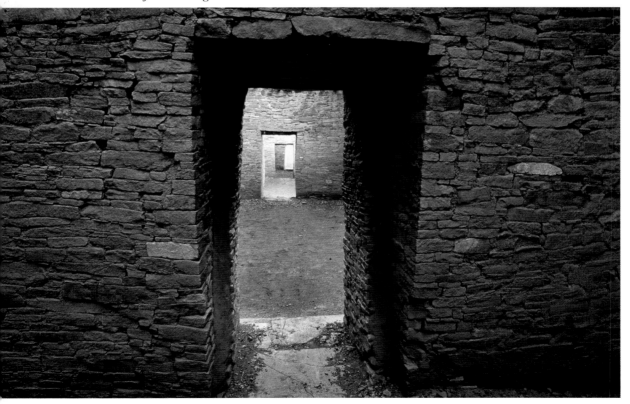

of depth between doorways. Another example is an image taken from inside a ceremonial kiva at Pecos National Historical Park, also in New Mexico. In the kiva shot we used reflected light as the main source but added drama with direct light flooding through the entrance. When setting up a shot like this, be careful to balance the different light sources carefully so as not to overexpose areas. Use just enough direct light to spike interest, and bracket freely to achieve the final result.

Direct Light

The striking colors of the Southwest generally do not photograph well under direct light, which lacks color contrast, bleeds texture, and eliminates shadows, all key elements for successful images. We generally avoid shooting in direct light and instead spend midday hours exploring backcountry locations or investigating unique and different angles for primary subjects.

One exception to the rule against shooting in direct light is inside deep canyons, like the Grand Canyon, Canyon de Chelly, or at sites like Betatakin Ruins at the Navajo National Monument, Cliff House Ruins in Mesa Verde, and Butler Wash Ruins in Utah. These sites, among others, are situated either on the canyon floor or on canyon walls. They are often best illuminated in the reflected light of midday. Uniform light or light without heavy shadows occurs selectively in most canyons, usually when the sun clears the canyon rim or is directly overhead. Over the years, we have struggled with intense shadows inside canyons and quite often resort to shooting long exposures either just before sunrise or just after sunset to get balanced light. We find this approach to be both technically challenging and productive.

The Spider Rock shot shown here was exposed about fifteen minutes before sunrise. The thin clouds above the canyon were illumi-

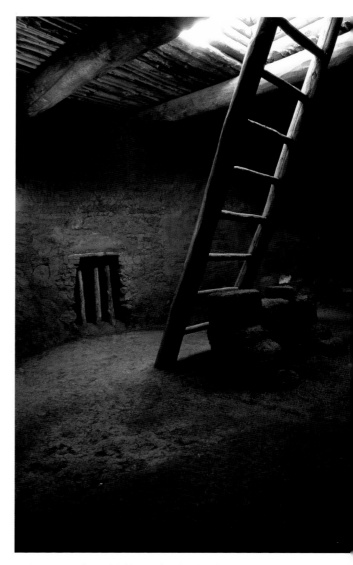

Using a number of different kinds of light, such as reflected, diffused, and direct, can yield interesting results. In this image taken inside the Great Kiva at Pecos National Monument, both direct and reflected light are effectively employed.

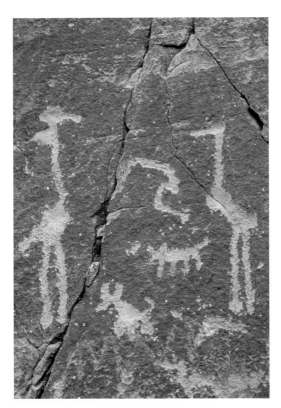

The petroglyphs at V-Bar-V Ranch Petroglyph Site are some of the clearest rock-art images found in the Southwest. Pick the time you photograph here carefully, since the right light is critical for capturing this type of ancient art.

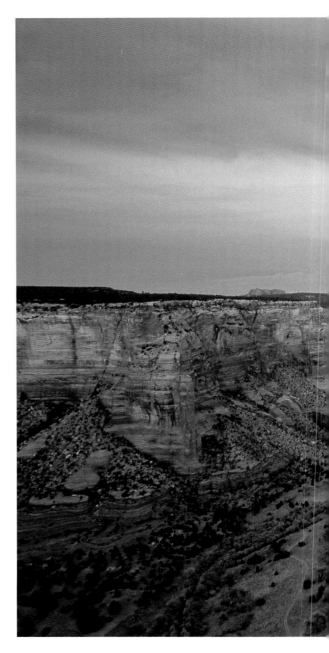

nated by early reflected light. Our goal was to blend the colorful sky with the dark canyon below and balance both light sources. To do this we used neutral-density filters making up a three-stop difference between the clouds and Spider Rock. We used large glass Tiffen filters. The original meter reading came from Spider Rock; comparing that to the clouds gave us the three-stop variance. With filters in place, we bracketed in increments of one-third stop for a full stop over and under the original meter reading. The gray side of the neutral-density filters held back just the right amount of light

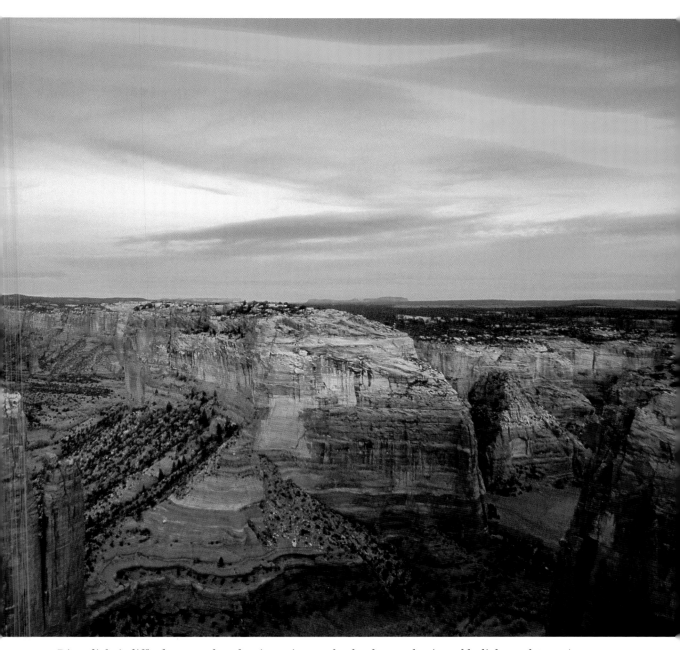

Direct light is difficult to use when shooting ruins or other landscapes dominated by light sandstone. A couple of exceptions are when direct light is reflected within the canyon, or when it is reflected off the earth just before sunrise or following sunset. This magical shot of Canyon de Chelly's Spider Rock was photographed just before sunrise.

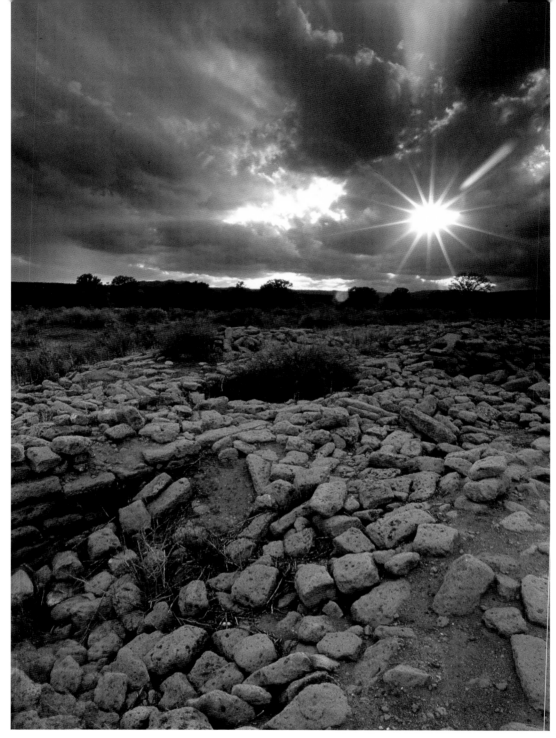

Tsankawi Ruins at Bandelier National Monument is challenging to photograph because little remains of the original structure. To add interest, we shot it with the light coming directly into the camera lens. We allowed a star to develop and used a warming filter to warm it up just a touch.

to balance the sky with the canyon. Bracketing provided the exact mood and tone.

In a digital format we could have achieved a similar result by turning to high dynamic range (HDR), which requires a series of images taken over the three-stop range. Eventually they are merged in processing.

Here is how to accomplish the Spider Rock shot using HDR. Remember the three-stop difference. Start the series of shots one stop over the Spider Rock meter reading and, in half-stop brackets, decrease exposure to allow for the bright sky. Continue bracketing, ending one stop under the metered sky. We use either shutter preferred or manual mode in HDR so as not to influence depth of field when bracketing. We also lock the mirror up and use a remote release to eliminate any possibility of camera movement. For both techniques, a tripod is necessary.

Backlight

For ruins, another creative light source to consider is backlight, which comes directly into the lens. This source quite often adds a mysterious or eerie feeling to ruins. For best results, bracket freely at least one over and under the meter reading. For backlit shots, we recommend a warming filter. The beginning meter reading is generally taken from the backlit subject. The evening image of Tsankawi Ruins illustrates the effect.

Sunrise and Sunset

Before we close our discussion on light, we must reemphasize the magic of sunset and sunrise; in the Southwest, these are optimal times for photography.

After chasing light for most of our adult lives, we admit to being hooked on sunsets and sunrises. Nothing adds to the natural drama of the Southwest more than a display of colorful sky. Bracket these shots freely, taking the original meter reading from both the dark and bright areas in the image, then averaging the reading somewhere in between.

Equipment

Cameras: Digital or Film?

It really doesn't matter what type of camera you use or whether you prefer film or digital; the information on technique we provide in this guide relates to photography in general.

A decade ago Cathie and I relied on color transparency film, but as times changed we turned to digital. Cathie switched first and got a head start. Being a few years older, I bowed my head and swore up and down that I would die with my 4x5 Linhof in hand. But when I witnessed the computer magic that Cathie performed on digital images, I quietly surrendered and bought my first digital. Make no mistake, I still cherish my Linhof; but today it sits on a shelf above my computer surrounded by old light meters, a broken dog whistle, and my grandfather's treasured brass compass. There it sits while I wield my own magic wand using software programs like Photoshop 5. Today my workhorse camera is a Nikon D700, and I often wonder what took me so long to release the digital muse within.

But no matter the type of shooting you prefer, digital or film, good photography, particularly landscape imagery, is based on the same fundamental rules, and heeding them is a good deal more important than equipment. More sophisticated cameras like the D700 or the Canons that Cathie prefers will of course give you more control over the final image, but sound photography encompasses so much more than the type of camera you use.

Warming Filter

A warming filter added to the lens is a must when shooting in shade or under overcast con-

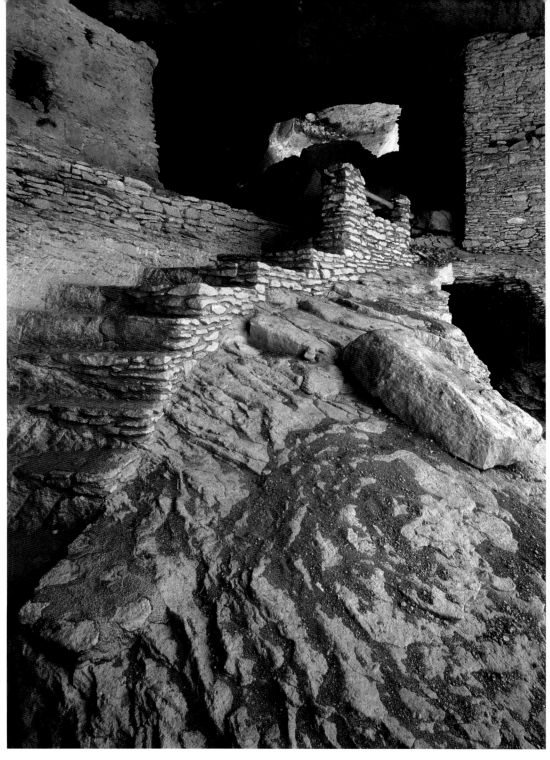

Inside New Mexico's Gila Cliff Dwellings, the photographer is faced with highly reflected light coming through a few small openings. This light is often dominated by a blue cast and should be warmed up.

ditions. It provides a pleasing tone to backlit subjects. These filters, known as 81A and 81B, remove distractive blue cast naturally occurring in diffused or shaded light. A good example of this effect comes from inside Gila Cliff Dwellings. The interior of the dwellings is illuminated almost exclusively by reflected or diffused light. If a warming filter had not been added, the shot would have been flooded with blue. Notice in the top half of the image where outside light enters the scene. There the light is gold as a result of the warming effect.

In digital, the same or very similar effect can be achieved by adjusting the camera's white balance to a warmer shooting selection. My Nikon identifies these settings as incandescent, fluorescent, direct sunlight, cloudy skies, shade, et cetera. Additionally, during processing you can add or subtract warmth.

We prefer to adjust color temperature in the field particularly when we shoot in "camera raw," which we do almost exclusively for landscapes. We like to see what we are getting on the camera's monitor. If you shoot in JPEG format, you should consider the fact that some ambient color is permanently embedded in the electronic image and on occasion almost impossible to eliminate during processing. Getting the image right in the field is particularly important for JPEG shooters.

Polarizing Filter

There are two creative uses for polarizing filters, and each applies to digital as well as film photography. Keep in mind that polarizing filters are effective only when light comes at the lens from an angle, regardless of how slight. By polarizing light, the photographer can darken skies or saturate certain colors in the spectrum. This filter is helpful when photographing ruins and other sandstone subjects because it intensifies color, increases contrast, and adds a sense of texture. The filter also reduces glare

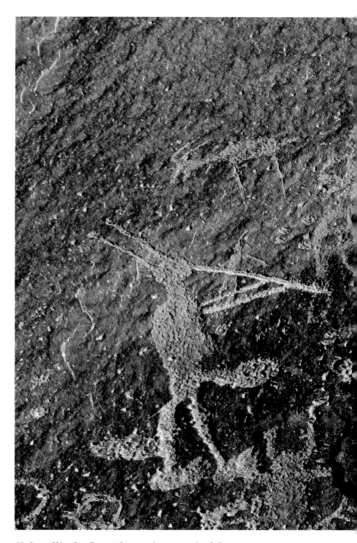

Kokopelli, the flute player, is a magical figure throughout the Southwest. Here his image is virtually lifted from sandstone with the aid of a polarizing filter. Light coming from the side is polarized, allowing the saturation of colors. The filter also removes distractive glare from the bight stone.

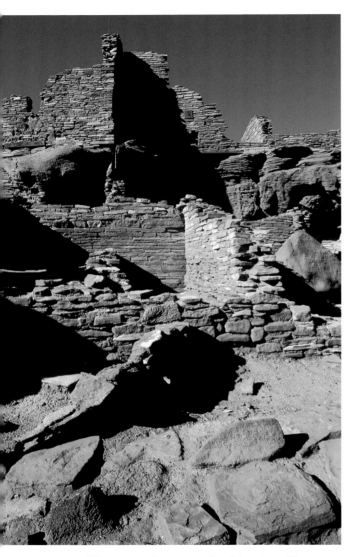

The spectacular array of prehistoric artifacts in Arizona's Wupatki National Monument is striking. Among the attractions some, like Wukoki Ruins, feature beautiful foregrounds oftentimes darker than the pueblo itself. A one-stop neutral-density filter was used here to balance the tonal difference between foreground and background.

on shiny surfaces, a tremendous advantage when shooting rock art.

To enhance the image of pueblo ruins against open sky, polarize the light and watch the warm hue of sandstone deepen as the sky darkens.

Graduated Neutral-Density Filter

Thousands of our nature images over the years have been composed through split neutral-density filters. These filters balance tonal differences in certain parts of a scene, such as between shaded foregrounds and bright main subjects. We use large Tiffen glass filters attached to the lens by Cokin holders. These crystal-clear filters are tinted gray on one end and come in densities rated in f-stops. We carry both one- and two-stop filters and on occasion combine both to provide three-stop coverage. On most occasions we prefer neutral-density filters to high dynamic range (HDR) imaging.

The effect of a one-stop graduated neutral-density filter can be seen in the image of Wukoki Pueblo.

Tripod

Cathie and I have worked in landscape photography for most of our adult lives and offer no apology for being "old school." We use tripods on practically all our landscapes—it's just that simple. A sturdy platform enables us to compose tighter, create sharper images, and slow things down.

Lenses

As landscape photographers we have relied on a number of different camera systems over the years. One thing is certain, however: our use of wide-angle lenses has grown substantially. In the final stage of film we carried SLR lenses ranging from 20mm to 300mm. For digital, even with "full-frame sensors," we now rely on lenses from 10mm to 300mm. The increased

use of wide angle perhaps comes from our growing reliance on strong foregrounds in composition.

Composition

Do you sometimes wonder, when you photograph with more advanced photographers, why their images have a certain flair not apparent in yours? It could be that they understand some fundamental rules of composition and use them in the field.

Before we hit the road to photograph the fascinating antiquities of the Four Corners region, let's spend a few minutes on some basic rules of composition.

The Rule of Thirds

Balance, in any work of art, is critical. To help achieve balance there is a simple rule relating to the placement of primary subjects inside the frame. Locate your primary subject in one third of the frame as opposed to the center. This might seem complicated but really it is very simple. In your mind's eye divide your camera's viewfinder into thirds, first from left to right, then top to bottom. When composing, remember the division of space and locate your primary subject in one of the three imaginary zones, either horizontally or vertically. If you draw the thirds on a blank piece of paper it might help you to visualize the division.

We were hiking early one morning in Utah's North Mule Canyon and discovered a secluded granary nestled inside a dark alcove. In composing the shot we used the rule of thirds. The granary is the primary subject and is located in the bottom third of the frame. Surrounding elements lead the eye directly to it, spiking interest. As a side note, both the ruins and alcove ceiling were in shade and required a long exposure on a tripod. A warming filter was added to eliminate blue.

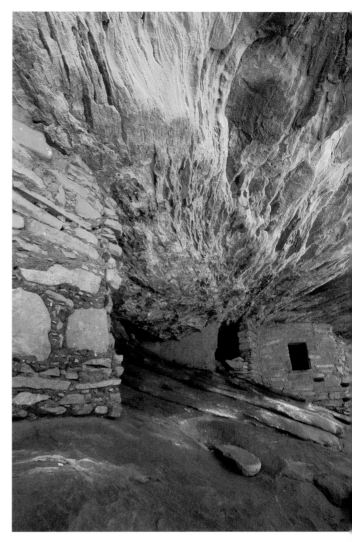

A ceiling of bright rock ascends above a hidden granary in North Mule Canyon. To emphasize the spectacular effect we relied on the compositional rule of thirds and placed the granary in the lower third of the frame.

Sufficient and Interesting Foregrounds

One of the most valuable lessons we learned in the Southwest concerns the use of complementary foregrounds. The strength of any image depends on drawing attention to the principal subject. Guiding your viewer's eye toward the primary subject by way of an interesting foreground can make for distinctive images. The shot of Merrick Butte in Monument Valley is a good example. Notice how we used the rule of thirds in the placement of the butte, as well.

Painting with Light

As we've discussed, flat terrain like that found in the Four Corners region can yield incredible light for photography, especially in early morning and late evening. During these prime times, concentrate on the effect bright, warm light has on key compositional elements. Use the light's brilliance as well as shadows to add drama and heighten attention to primary subjects. The image of Tree House Ruins in Colorado's Ute Mountain Tribal Park is a good example. The bright light and texture in the foreground pulls the viewer's eye to the ruins situated in the top third of the frame.

Now that we've got the basics down, let's pack our bags and hit the road. Along the way a host of primitive cultures will guide us along, share their art, and introduce us to their ancient dwellings. We begin our photographic adventure at a special site in Utah.

Monument Valley has always attracted photographers. The effective use of foregrounds can help set your images apart. Here Merrick Butte and the Mitten Buttes are in the distance foregrounded by beautifully illuminated wood. For this shot we used a polarizing filter to darken the morning sky.

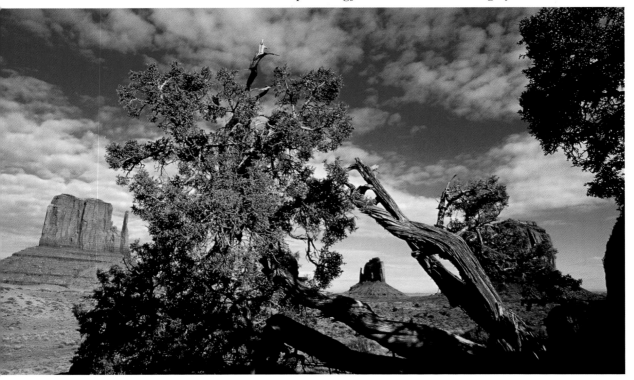

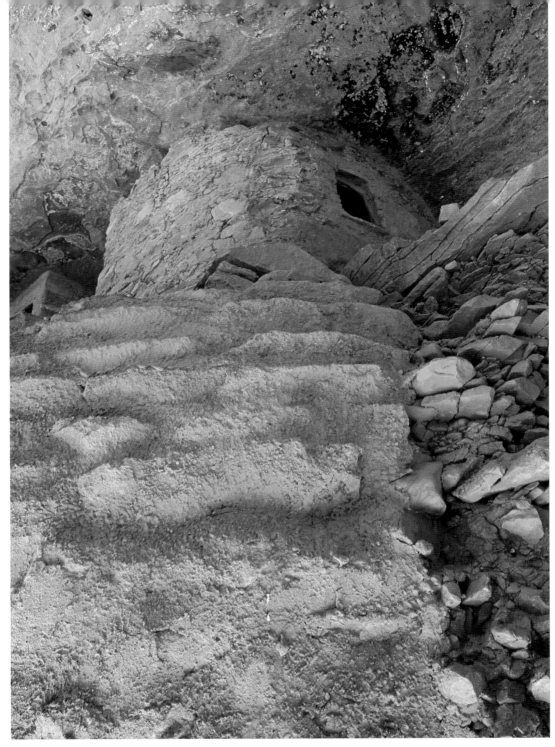

Light is the photographer's palette. It can turn a mundane image into a living masterpiece. The ruins at Ute Mountain Tribal Park often appear in open shade. Select the right time of day to photograph at such locations and remember that your results will depend on the creative use of light.

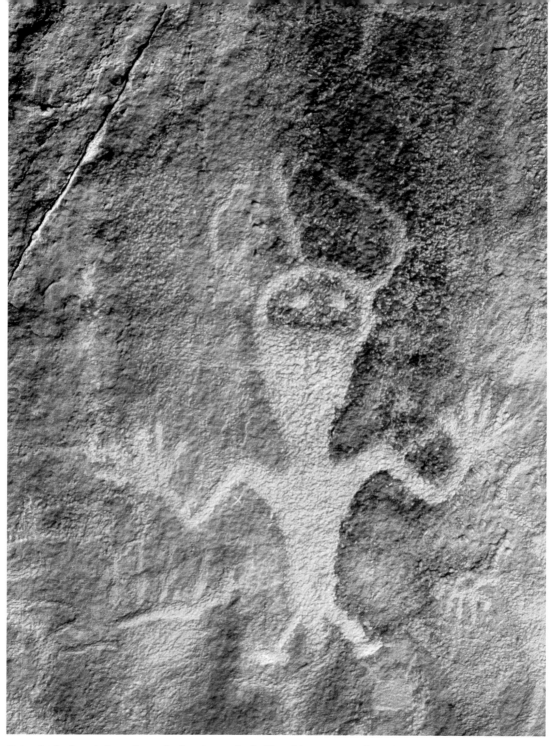

Petroglyphs found throughout the Southwest, including this one at Swelter Shelter, Dinosaur National Monument, often include human figures with antennae-like appendages. Some experts wonder if this is not the work of ancient shamans boasting a connection to other worlds.

I. Utah

1. Dinosaur National Monument

Inside the 210,000-acre Dinosaur National Monument you'll find an impressive mix of natural and cultural treasures, including geologic features millions of years old, the bleached bones of prehistoric dinosaurs, and a captivating collection of rock art left by Fremont Indians.

Legend has it that the Fremont, ancestors of the Ute and Shoshone, passed through this area while journeying to their permanent home in present-day Wyoming and Idaho. Their pilgrimage was inspired by religious traditions promising a sacred homeland to the north. As they traveled, they created petroglyphs chronicling their migration.

A number of impressive galleries are found in Dinosaur National Monument. Many of the best and most accessible are along the Tour of the Tilted Rocks, an 11-mile (one way) auto tour just inside the protected area. The tour takes a couple of hours to complete and is a great way to experience the remarkable rock art of the Fremont.

The first petroglyph panel is located at **Swelter Shelter (2)**, a name derived from the intense heat in which excavators worked as they arduously uncovered the region's ancient past. Farther along, at **Mile Marker 14 (3)**, another panel comes into view on the sandstone cliffs above the road. It features large lizards appearing to crawl across the smooth surface. A short trail leads from the pull-off to the cliffs and an assortment of other images.

Other sites of interest not on the Tilted Rocks tour include the petroglyphs at **McKee Springs (4)**, located on Island Park Road just north of the town of Jensen. Travel UT 149 to Brush Creek Road, turn left, and proceed to Island Park Road. On Island Park Road turn right and continue 4 miles until the road splits. Bear right and continue another 11 miles until the road narrows. Look for the petroglyphs on the right.

Another great site to photograph is **Deluge Shelter (5)**. It is near the fish hatchery on Jones Hole Creek. From the town of Vernal, take the Jones Hole Road to the hatchery and trailhead. There, a 1.75-mile trail follows the creek and leads to a number of panels with interpretative signs.

When photographing rock art sites it's important to seek the right type of light. Consider utilizing strong sidelight and a polarizing filter.

6. Dry Fork Canyon

The huge Navajo sandstone cliffs rising above Dry Fork Canyon tell a primordial story of erosion and the coming and going of ancient oceans staged over millions of years. On the face of the cliffs are etched the story of early Fremont hunters who occupied the canyon after A.D. 500. Rock art in the canyon and in particular on the McConkie Ranch is considered among the most complete and well preserved anywhere.

The site at McConkie Ranch is easily photographed from a winding trail along the cliffs. It begins behind the information hut at the head of the parking lot and continues to one interesting petroglyph gallery after another. Images include anthropomorphic figures dressed in ornate attire complete with necklaces, ear bobs, and ceremonial helmets, and animals indigenous to the area. An array of hunting scenes is depicted.

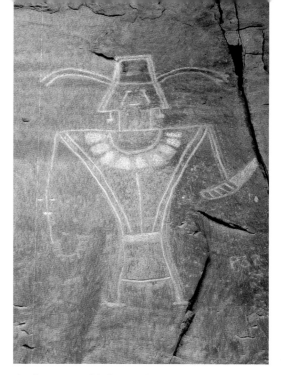

Anthropomorphic figures in ornate attire grace the collection of petroglyphs found at the McConkie Ranch in Dry Fork Canyon.

Use of a polarizing filter when photographing these sites will help make the faintly etched figures stand out.

The site is on private land and maintained with the help of donations; please do your part to help. And remember, with viewing the art comes a personal responsibility: photograph it, enjoy it, but please don't touch it. The oil from human fingers can rob life from these ancient relics.

7. Nine Mile Canyon

We access Nine Mile Canyon from Wellington, Utah, and travel the 40-mile gravel road to Myton. It is helpful before embarking on the trip to pick up a guidebook, because much of the land along the way is private property. Guidebooks are available at several locations

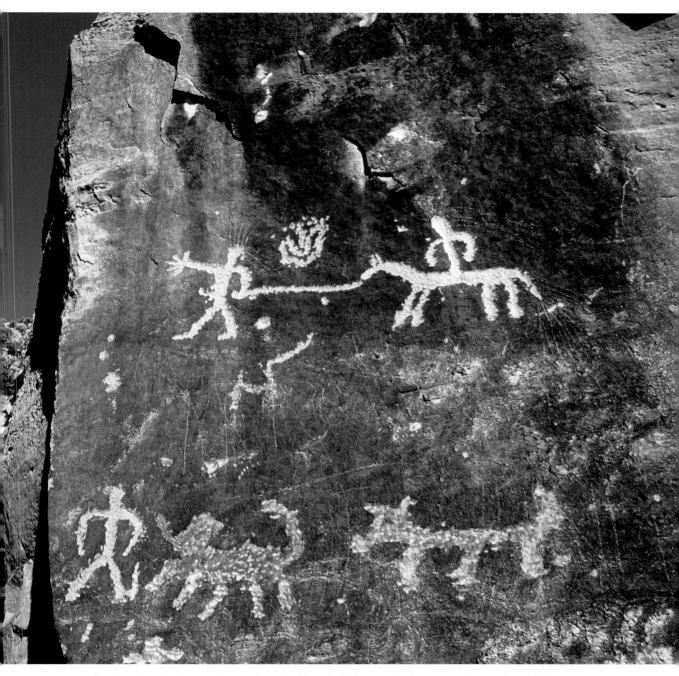

As in other locations in Utah, the petroglyphs in Dry Fork Canyon depict human figures dressed in ceremonial garb complete with headgear, ear bobs, and fancy necklaces. The art also shows various animals common to the area.

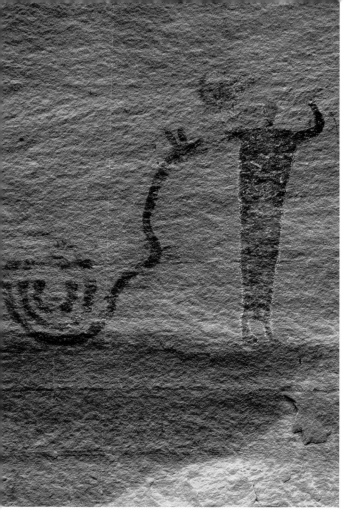

Buckhorn Wash rock art includes both petroglyphs, which are chiseled or etched in stone, and pictographs, which are painted. The paint used was made from natural minerals, plants, and even animal blood.

hunters. In the middle of the herd is a human figure believed to be an ancient shaman, there to ensure the success of the hunt.

A longer lens is helpful in obtaining good images of the rock art here. When shooting petroglyph panels like these make sure to bracket sufficiently to account for the light sandstone walls and faint imagery. For balance, alternate your shots to include close-ups and landscape compositions.

8. Buckhorn Wash

The remote Buckhorn Wash rock art site is a must for any Southwest photographic collection. This extensive panel displays a mosaic of two different cultures separated by thousands of years. The first to arrive in the wash were the Barrier Canyon people. These nomadic bands traveled most of the year, and it is believed they gathered in the wash to partake in religious celebrations, yielding the two-thousand-year-old pictographs preserved on the surrounding walls. A second group, the Southern San Rafael Fremont, arrived around A.D. 600. Anthropomorphic and zoomorphic inscriptions include birds, mammals, and reptiles. In producing these petroglyphs, ancient artisans used flint chisels and stone hammers in their work.

The red pigment of the pictographs at Buckhorn Wash stands out well in strong sidelight with the use of a polarizing filter. We also recommend a tripod. Give yourself plenty of setup time to get the light just right.

9. Sego Canyon

Located just north of the town of Thompson Springs, Utah, Sego Canyon offers a large collection of art from three distinctly different cultures. Etched and painted on three individual panels are the archaic work of Barrier Canyon artisans on the east-facing panel, Fremont artists on the south-facing panel, and the more

in Wellington. The rock art in the canyon was left by the Fremont people and includes a display of prehistoric hunting scenes. Along the route you will come to Cottonwood Canyon, easily identified in your guidebook. Here you will encounter the famous Hunting Scene Petroglyph Panel, which depicts a herd of bighorn sheep about to be ambushed by Native

contemporary work of the Ute Indians directly in front of the parking lot.

Experts believe the Barrier Canyon pictographs could be the work of shamans who led their followers to the canyon in pursuit of wild game and plants. The hunters probably visited for short periods as far back as six thousand years ago. The scenes painted on the east gallery depict anthropomorphic beings rising ghostlike from the rock itself. They have hollow eye sockets, horns or antennae, and are absent arms and legs. The reddish pigment used for the ghoulish group comes from natural plants and minerals found in the area.

The Fremont art to the south is very different from the Barrier Canyon work. It is made up of petroglyphs (pecked) as opposed to pictographs (painted). Like other Fremont sites, Sego Canyon records the passage of hunter-gatherers as they returned seasonally to certain places of abundance. Notable in this gallery is an overlapping of art, one petroglyph etched atop another, perhaps marking each seasonal return.

The final art at Sego Canyon is the work of Ute Indians. Interestingly, scenes here include horses, which serve to date the work to sometime after 1600, when horses were first introduced by Spanish conquistadors traveling north from Mesoamerica.

The three individual panels found in Sego Canyon offer a unique challenge for the photographer. Here is a rare opportunity to record the work of completely different artisans. A tri-

The horse was introduced into the Southwest sometime after 1600, a fact that helps us date the work of the Ute artisans who left images of these animals in Sego Canyon. Other panels here go back farther in time, possibly chronicling some of the earliest humans to arrive in the region.

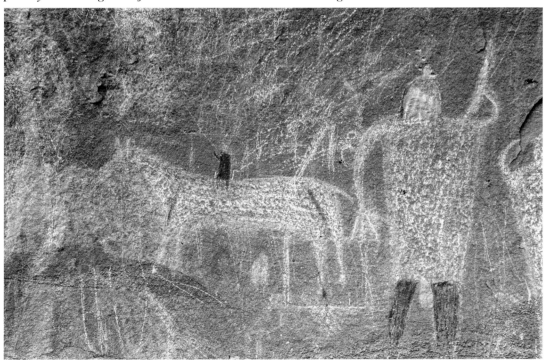

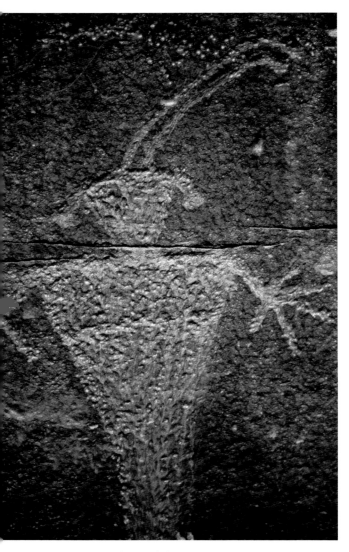

Located east of the visitor center along the Fremont River, a rock-art panel in the Fruita Historic District portrays ancient figures dressed in unusual garb. The art here is the work of the Fremont Indians, among the first to farm the rich floodplain. Today, one attraction of the the site is the fruit trees adjacent to the petroglyphs.

pod is recommended for longer lenses as well as decreased shutter speed required by a polarizing filter. Polarizing sidelight will heighten the reddish pigment used on pictographs while increasing contrast, making the petroglyphs stand out.

10. Capitol Reef National Park

Landscape enthusiasts are typically drawn to certain areas. For Cathie and me, Capitol Reef National Park is our special place. Prehistoric farmers were attracted to the area as early as A.D. 700 and survived for six hundred years hunting deer, bighorn sheep, and rabbits while harvesting crops and wild plants on the fertile Fremont River floodplain. Their presence is felt today in the remote areas of Bentonite Hills, Oak Creek, and the breathtaking Cathedral Valley.

Some of the most accessible examples of Fremont presence are the petroglyphs located in the Fruita Historic District of Capitol Reef. Here a wooden walkway borders the rock art and provides a close-up view.

When photographing here, bring a longer lens such as an 80–200mm zoom or a point-and-shoot camera with telephoto capabilities to isolate individual etchings. As you work, take note of the larger surroundings; directly across from the walkway is a lush meadow with lovely fruit trees, spectacular when in full bloom. Farther down the road you will find the ruins of an old granary nestled beneath a sandstone overhang.

As at most sites, it is beneficial to stop at the visitor center before you begin photographing, to acquaint yourself with the natural history and human legacy of the place.

A few miles from the western entrance to Capitol Reef National Park is the town of Torrey; UT 12 leads to Boulder and our next stop, Anasazi State Park.

11. Anasazi State Park

Among the ancients inhabiting the Four Corners region, the Anasazi culture was the largest. Traces of their presence overlap all four states in the region. Archaeologists divide the Anasazi into a number of groups ranging from Basket Makers I through III and onward to the Pueblo era, which is subsequently divided into five distinct periods. The people are further split by the geographic area they occupied—the Chacoan from Chaco Canyon, the Mesa Verdean, and the Kayenta, originating near Kayenta, Arizona. Many of the prehistoric ruins observed on the Southwest landscape speak to the existence of this fecund culture.

The Coombs Site at Anasazi State Park is an example of Kayenta Anasazi occupation. Experts believe they chose the region for its rich soil and plentiful water for agriculture. Abundant native flora and wild game also made the area attractive. The site at Coombs probably housed some two hundred inhabitants during its heyday. The site includes both earlier subterranean pit houses and pueblo dwellings built of stone and mud mortar from a later period. The pueblo includes the remains of a 34-room L-shaped complex complete with storage rooms.

Coombs was occupied from A.D. 1050 to 1200. The site was eventually destroyed by fire. Combustible materials used in construction caused the catastrophe. Once leveled, the village was never again occupied.

Before photographing this site, spend some time in the small museum. Consult park staff about the possibility of doing some still-life images using existing light. A tripod is necessary as well as filtration or white-balance adjustment to compensate for interior light. We like to arrive at Coombs when it first opens, to take full advantage of interior shots without disturbing other visitors.

Those who first came to the Southwest lived in subterranean pit houses like those refurbished and on display at Anasazi State Park. Photographing the interior of these structures can be a challenge due to the lack of light. We find it best to include some exterior light when photographing interiors, to add a sense of depth and interest.

12. Arches National Park

As with other national parks in the Southwest, it can be difficult to take your eyes off the amazing natural scenery at Arches long enough to adequately read the human story inscribed throughout. The goal here is to somehow mix the two dimensions photographically and come away with a unique set of images. The ancient ones who roamed the semiarid lands of the Four Corners region were undoubtedly as impressed as we are today by the majestic geologic forms sweeping across the landscape of what we today call Arches National Park.

The best way to find your way around these prehistoric sites is to ask for information at the visitor center. Undoubtedly one of the locations you will learn about is **Wolfe Ranch (13)**. The petroglyph panel here is very accessible to photographers and includes hunting scenes with Native pursuers mounted on horses.

There are hundreds of other rock art specimens scattered throughout the park, so if you decide to hike the backcountry here, keep a sharp eye out for them. If you do decide to go farther afield, don't forget your tripod. It will be worth the extra effort to lug it along if you discover a hidden petroglyph just waiting for your photographer's eye. Remember, however, not to touch these remote panels.

14. Moab Rock Art Sites

The bustling town of Moab is located near the entrance to Arches National Park and between various districts of Canyonlands National Park. Its sandstone geography contains a large number of interesting rock-art panels that are accessible and easily photographed. Among the galleries, three come immediately to mind: **Courthouse Wash (15)**, located 4 miles north of Moab, **Potash (16)**, and the **Golf Course (17)** site just outside town. Each of the panels

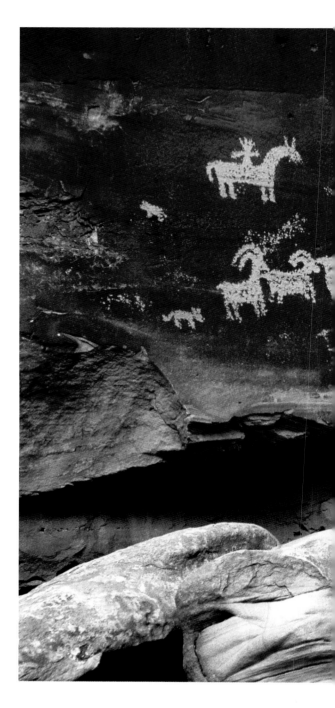

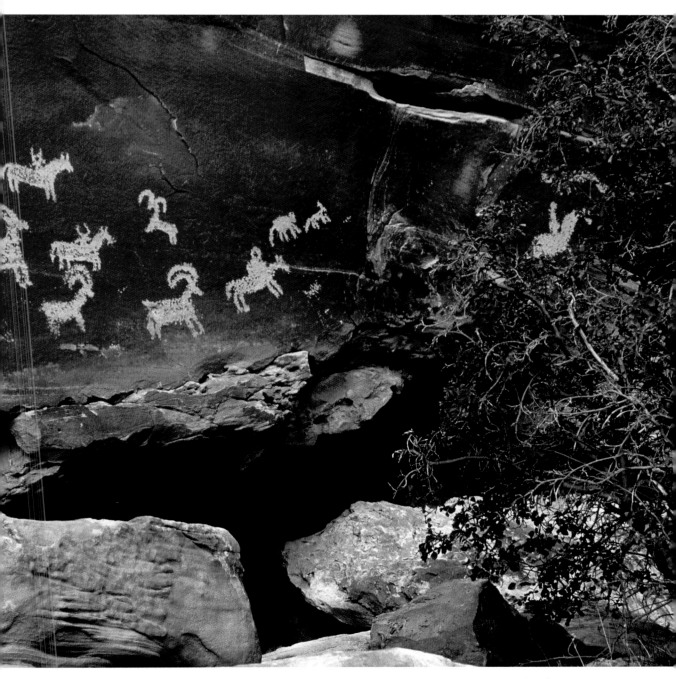

Studied closely, the Wolfe Ranch petroglyphs display a vivid hunting scene common to many Southwest panels. Here, sheep are the game of interest and the hunters are mounted on horses, which helps to date the panel.

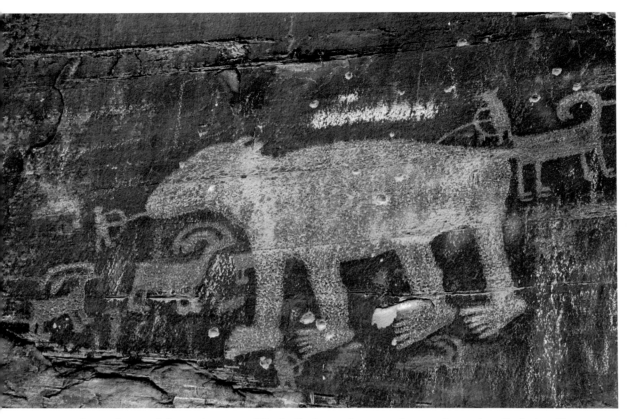

Located around the quaint town of Moab, Utah, are three prominent rock-art sites. Each site offers a unique example of art spanning from the Barrier Canyon era to the Fremont era. The art includes both human and animal subjects, including this prominent bear from the Potash site along the Colorado River.

demonstrates the work of two cultures, the prehistoric Fremont and the more modern Ute. Both the Courthouse and Golf Course sites are close to town, while the Potash panel is along Potash Road and the Colorado River.

Early evening, when the light is low, is a good time to photograph around Moab. A polarizing filter and tripod are helpful, and a longer lens to isolate individual images is a must. The figures included in all three panels range from eerie humans rising from the rock's dark patina to nicely formed animals including bighorn sheep, reptiles, and bears. Moab's rock art speaks to a long occupation of Natives in the area, an occupation certainly extending into Arches and Canyonlands National Parks.

18. Canyonlands National Park

The incredible geography of Canyonlands National Park, with its deep twisting canyons and wild rivers, at first glance appears inhospitable to human habitation. The vastness alone intimidates. But human activity here dates back at least three thousand years.

Canyonlands is a prime cultural frontier zone, where the influence of two different cultures, the Fremont and the Anasazi, overlap. Although the photographer can find the re-

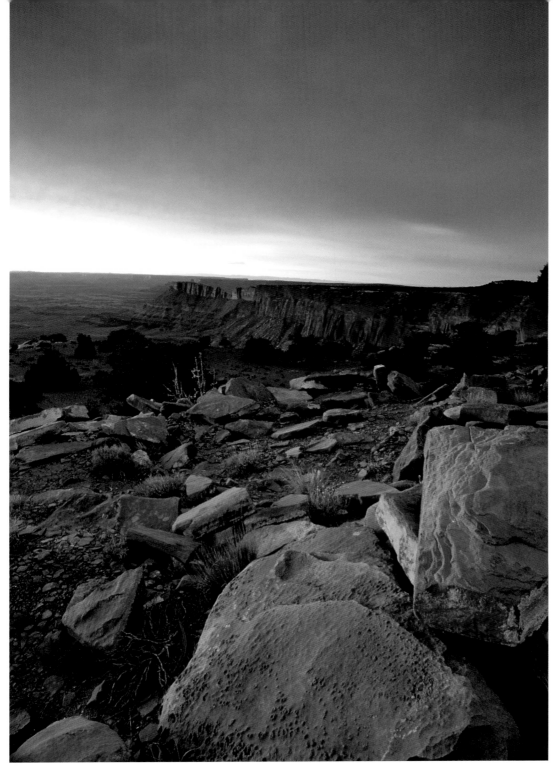

Needles District, Canyonlands National Park

mains of pueblo ruins and granaries such as Roadside Ruin in the Needles District, the most prominent example of prehistoric life perhaps rests in a proliferation of rock art found in more remote locations like Peekaboo Canyon. The best way to find your photographic way around Canyonlands is to stop at the visitor center and ask an expert. Some sites you might want to visit require backpacking permits, so come prepared for an overnight stay.

Three of our favorite sites are the **Great Gallery in Horseshoe Canyon (19)**, the **Bird Site (20)** in the Maze District, and the readily accessible **Cave Spring (21)** pictographs in the Needles District. At these art sites, a number of primitive techniques were employed by artisans. The use of fingers or crude yucca-fiber brushes to apply natural paint was a common practice, while another required paint to be blown through reed tubes sometimes creating a bias relief effect like those found at Cave Spring. The elongated trapezoidal figures gracing some Canyonlands sites are thought to be the work of shamans offering homage to otherworld deities.

Photographing in Canyonlands National Park, be it capturing the detail left by past artisans or the magnificent work of nature, is a matter of how you use the light. Morning and late evening are our favorite times to photograph here. Light patterns at the park call for the use of either split neutral-density filtration or HDR.

22. Newspaper Rock

Along UT 211, en route to Canyonlands National Park's Needles District, you will find Newspaper Rock, a site that experts have marveled over since its discovery. Between two hundred and three hundred individual images are inscribed on the rock and date back thou-

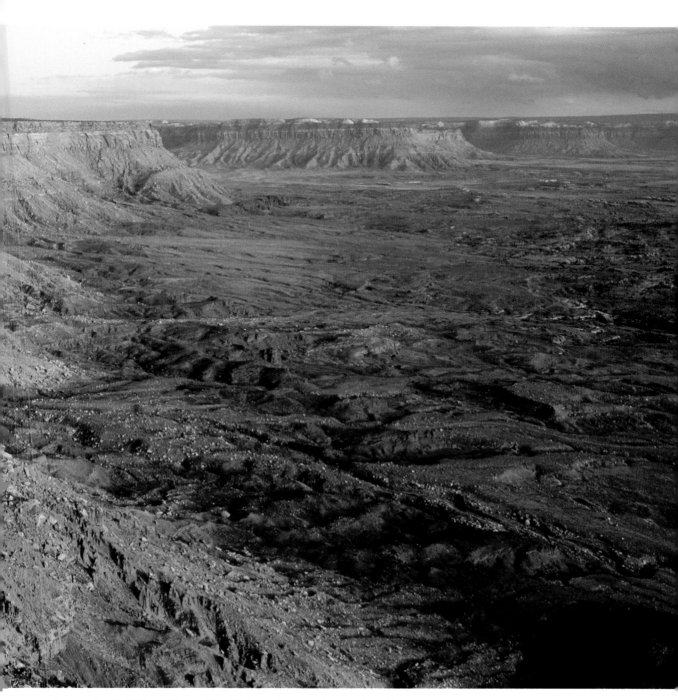

Canyonlands National Park offers photographers an impressive vista.

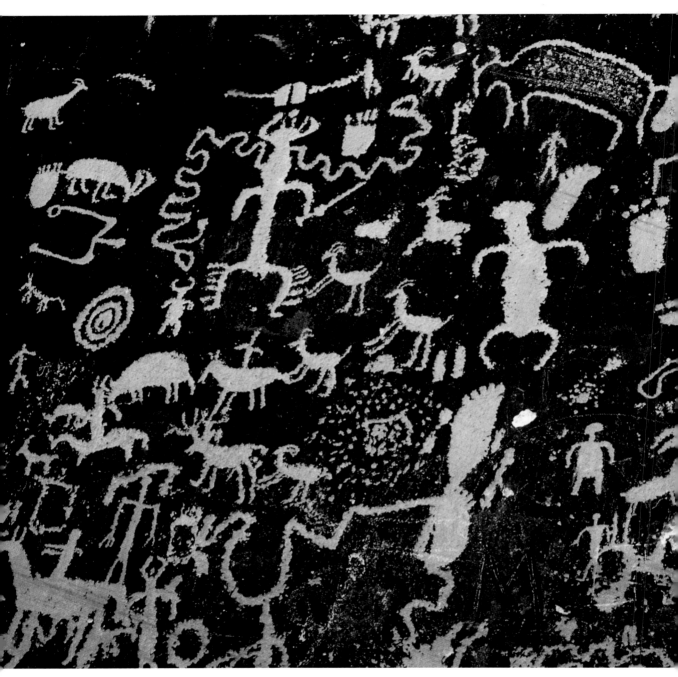

Certain Southwest areas seem to have attracted repeat visits by ancient hunter-gatherers. The montage of petroglyphs displayed on Newspaper Rock includes scenes composed by several Native cultures over thousands of years.

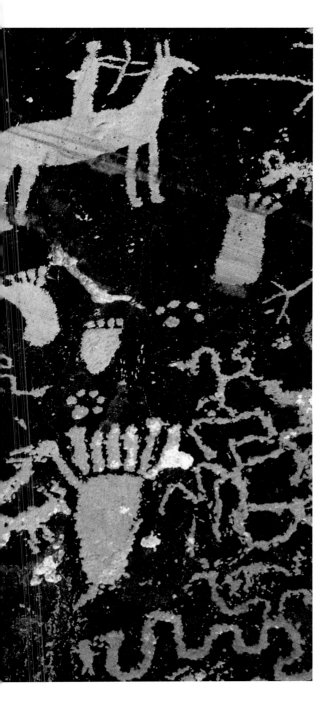

sands of years. Situated in a heavily wooded area that was ideal for hunting and gathering, the rock is believed to have been visited seasonally by hunters or during times when native plants gave up their bounty. The prehistoric inscriptions on Newspaper Rock tell a story of survival as well as the transmission of knowledge between advancing cultures.

Some of the art depicts hunting scenes, beginning with crudely composed stick figures and progressing to fully formed figures. The depiction of humans mounted on horses date some of the work to the late 1600s.

Hours can be spent at Newspaper Rock exploring and photographing the work of three different cultures. Archaic hunters were the first to peck their story into the rock's rich patina. They were followed by the Fremont and Anasazi centuries later. The final people to use the rock were the Ute.

This is a well-known site that is heavily visited, complicating the use of a tripod, so visit early or late to be here without the crowds.

23. Edge of the Cedars State Park

This small site is located on Cedar Mesa and, like others in the area, contains evidence of occupation by Anasazi farmers between A.D. 825 and 1220. The site's pueblo ruin is situated on a small ridge above the Westwater Creek drainage, no doubt an attraction to ancient agriculturists of the time. The ruin is believed to have housed as many as 250 people during its heyday. The village includes an array of ceremonial chambers including a Great Kiva. A trail beginning at the visitor center weaves through interpretive panels and provides several good photographic opportunities.

The site's location on a ridge makes it perfect for sunset and sunrise images. Low evening light and long shadows work perfectly

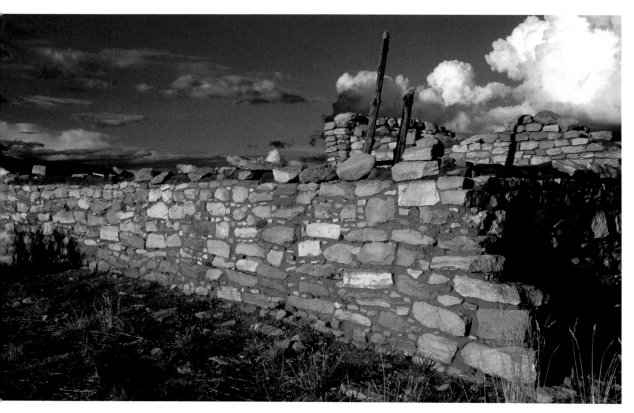

Located on the impressive Cedar Mesa, the pueblo ruins at Edge of the Cedars State Park were left by ancient farmers who were attracted to the area's abundant water and fertile soil. A polarizing filter helped darken the evening sky and enhance a bank of clouds over the scene.

to lead the viewer's eye into an image with a detailed foreground.

24. Butler Wash Ruins and Mule Canyon Ruins

These two impressive sites are close to one another on UT 95, west of its intersection with US 191. Both sites are marked and easy to find.

The cliff dwelling at Butler Wash is situated in a cave-like alcove above the wash. Photographing the village takes some study with regard to the timing of the light and the season during which you visit the area. For every season, however, there is a good time during the

day to catch the scene in balanced light. All it takes is to observe how the sun illuminates various parts of the wash as it crosses the sky. We like to include other elements at the location to highlight the dwelling's unique placement.

Mule Canyon Ruins is located farther along the highway and is a wonderful site to photograph and experiment with various kinds of light. We arrived one evening at Mule Canyon just as a summer storm was brewing overhead. We took advantage of light patterns developing from the storm. Anytime you get a thunderstorm in the Southwest it makes for great images, so keep your eyes heavenward and bracket

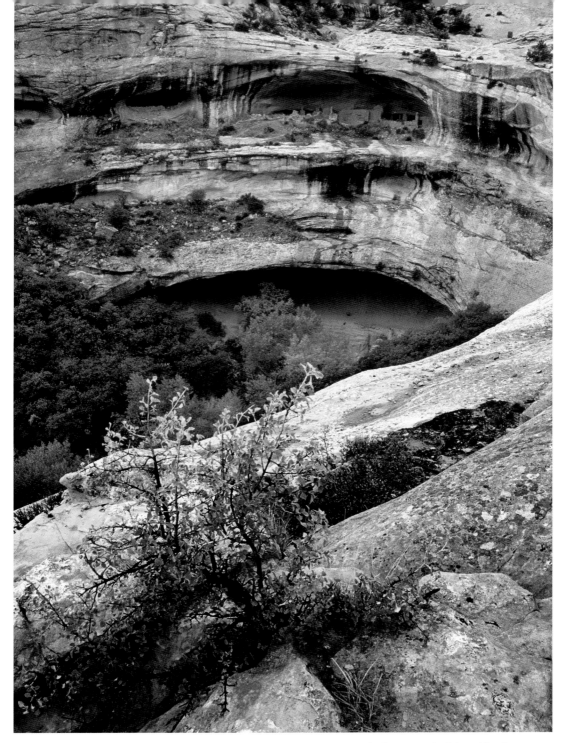

The cliff dwellings at Butler Wash. We like to use natural subjects in the foreground of shots like these to heighten interest. Light-colored stone can be a problem for photographers, so meter carefully and bracket for final effect.

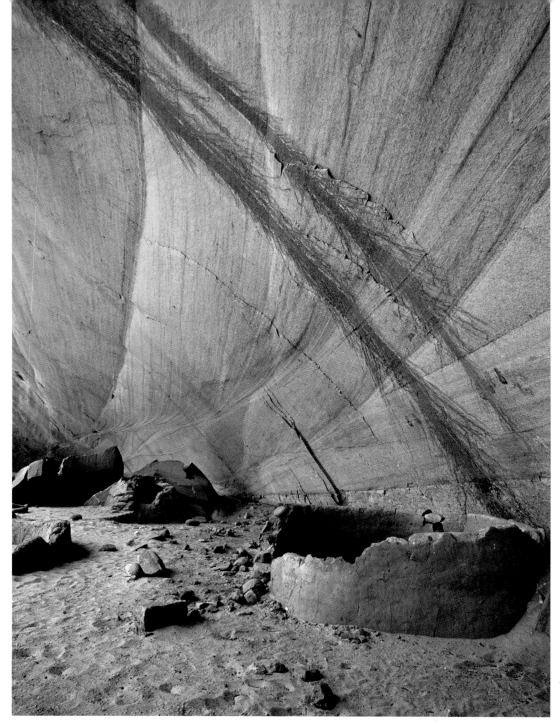

Scattered throughout the picturesque Natural Bridges National Monument are a number of prehistoric sites of photographic interest. Here a small granary at the base of a sandstone wall provides a beautiful image high in story value. The ruins at Kachina Bridge and Horsecollar Ruins farther up the canyon are perfect places to work in open shade, which provides a pleasing pastel effect to images.

freely during these times. We very often find that an image slightly darker or lighter than expected better communicates mood and turns an interesting scene into an outstanding one.

25. Grand Gulch Primitive Area

Some believe that the most complete collection of prehistoric ruins and rock art in Utah is found inside Grand Gulch Primitive Area. The gulch is a backpacker's mecca, accessible only by extensive hikes, overnight stays, or horse travel.

The gulch offers a wealth of photographic opportunities but presents a number of logistical challenges for the photographer. What equipment to take along on an extended backcountry trip and what to leave behind oftentimes determines the quality of images from remote places like the gulch.

26. Natural Bridges National Monument

Three of Utah's most spectacular natural bridges are located in the White Canyon area. In 1908, in an effort to protect these treasures, Theodore Roosevelt set aside Natural Bridges National Monument. The three natural bridges were later named Kachina, Sipapu, and Owachomo in tribute to Native peoples who had occupied the area.

Thousands of years before the arrival of Europeans to the West, ancient hunters explored White Canyon and eventually built modest pit house shelters. They were followed by the Anasazi, who built homes of sandstone and adobe mud on the canyon's rim. With the arrival of corn and other plants that could be cultivated, the farmers moved into the canyon, where they relied on seasonal moisture and perennial streams for irrigation.

A 9-mile auto tour follows the canyon's rim

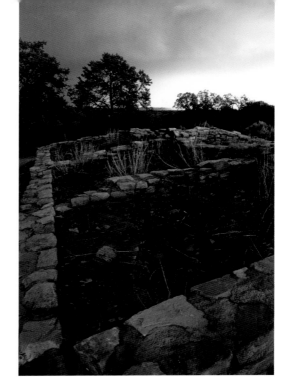

Prehistoric ruins at Grand Gulch Primitive Area

and offers a great perspective of the three bridges as well as a distant view of prehistoric sites like Horsecollar Ruins. At the **Kachina Bridge (27)** overlook, a short but demanding trail descends into the canyon. Here a more intimate view of Anasazi life unfolds.

The first leg of the trail leads to a rock-art panel and ruins situated in an overhanging alcove adjacent to Kachina Bridge. The art and ruins offer a remarkable photographic opportunity, a chance to work from a tripod in beautifully shaded light. Remember to warm your images with either a filter or white-balance adjustment.

The next section of trail leads to **Sipapu Bridge and Horsecollar Ruins (28)**, another great place to photograph. Horsecollar Ruins is also inside a shaded alcove, which can present a challenge given two different light sources illuminating the scene (shade and direct light)

—graduated neutral-density filters or HDR work well in this situation.

Remember, it is our collective responsibility to protect these remote sites, so please be careful, don't touch or disturb anything, and compose your images from a respectful distance.

29. Hovenweep National Monument

W. D. Huntington in 1854 penned the first record of the magnificent ruins at Hovenweep National Monument. By all accounts, however, it was photographer William H. Jackson who put the area on the map, twenty years later. Jackson's work in the Southwest remains an inspiration to modern photographers. He was the first to refer to the ruins as *Hovenweep,* a Ute word learned during his historic travels. In 1923 President Warren Harding celebrated the photographer's vision when he officially named the site Hovenweep National Monument. In addition to Jackson, legendary photographers like Ansel Adams, Eliott Porter, and Herbert Gleason have played critical roles over the years in the creation of national parks, monuments, and federally protected wilderness areas.

Hovenweep is under the stewardship of the National Park Service. The pueblo ruins are among the most photographed in the Southwest, raising the creative bar for today's photographer. After getting a feeling for the many attractions at Hovenweep, assess the light carefully. Some of the iconic attractions are located above the gulch, where warm early mornings and late afternoons are a delight. Low-angle light creates deep shadows, however, so plan accordingly. Cathie and I find our most pleasing images at Hovenweep to include detailed foregrounds leading toward ruins like Hovenweep Castle.

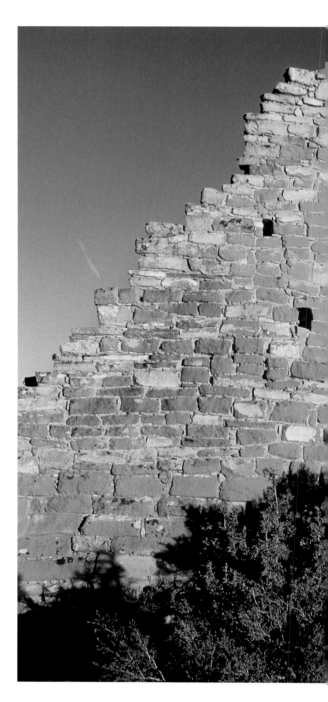

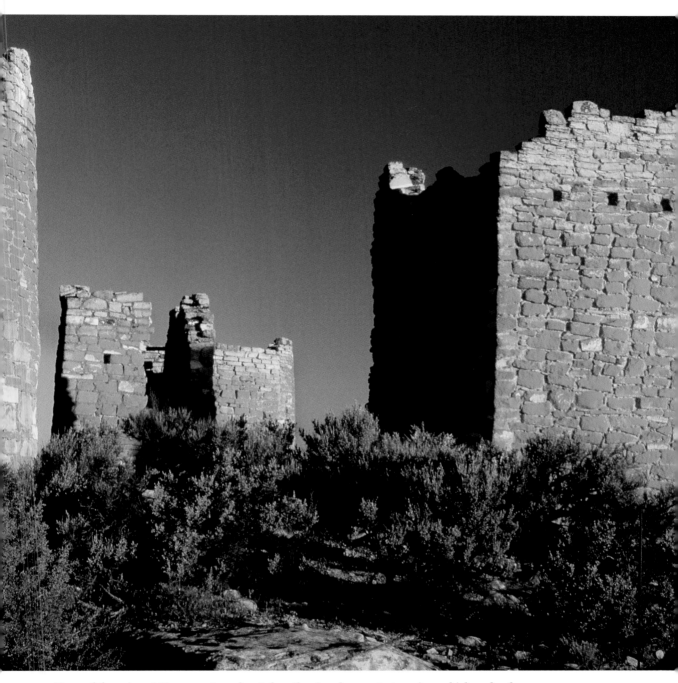

Many of the ruins at Hovenweep are located on the rim above a steep ravine, which makes for some wonderful light for early-morning and late-afternoon shots. Hovenweep Castle is best photographed using a strong foreground. Try alternating horizontal and vertical shots.

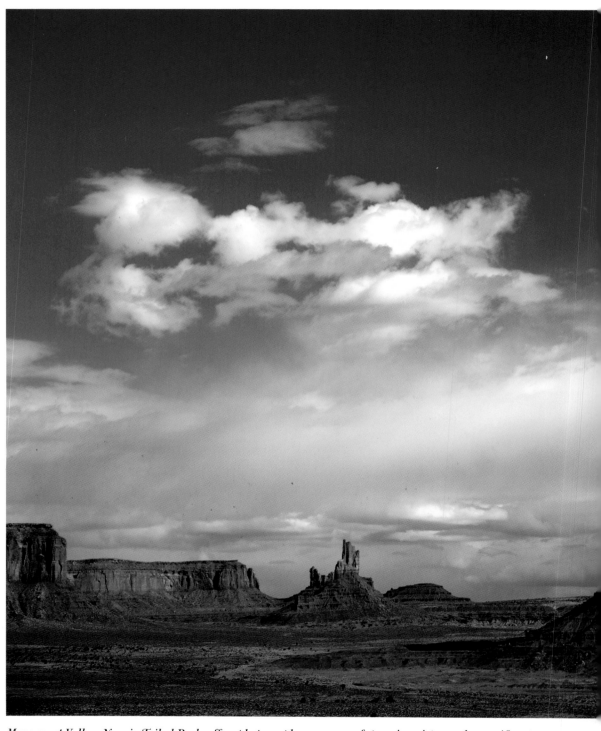

Monument Valley, Navajo Tribal Park, offers photographers a range of stunning vistas and magnificent sandstone landforms under atmospheric skies.

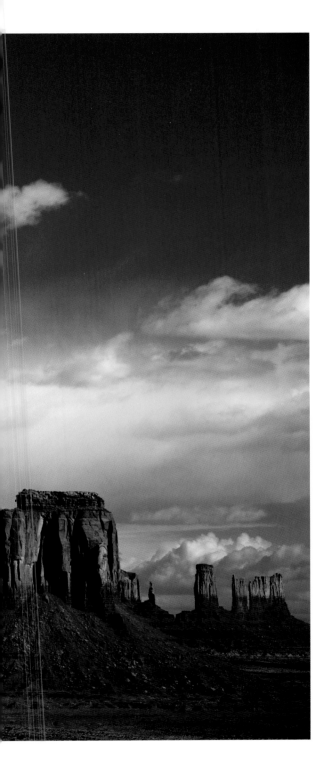

II. Arizona

30. Monument Valley Navajo Tribal Park

Monument Valley is one of the most mysterious settings in the Southwest. Its broad, sweeping vistas, towering sandstone buttes, windblown deserts, and bone-dry arroyos exemplify the harsh natural beauty of the West. The valley—which is actually 5,564 feet above sea level—has captured the attention of great artists, photographers, and moviemakers over the years. Of all the places we have photographed in the Southwest, Monument Valley is the most meaningful to Cathie.

To the Navajo People, the monument, which remains under Navajo stewardship, is sacred. Visitors must hire Native guides to gain full access to areas inside the monument, especially backcountry locations, ruins, and rock art. Such tours are well worth the expense, providing not only a close-up view of these sites but cultural and historical interpretation from people closely linked to the land and its legacy.

Experts believe the first humans to live in Monument Valley were Paleolithic wanderers, possibly over ten thousand years ago. They were followed by nomadic hunters sometime after 6000 B.C. Few traces remain from either occupation. The Anasazi were the first to record their presence in the form of rock art and small pueblo dwellings like Echo Cave Ruin. The Navajo people, or Dini (pronounced dee-NAY), consider themselves direct descendents of the Anasazi.

Tours begin at the park visitor center and take a couple of hours. Recognizing the splendid natural beauty and prehistoric significance of their homeland, Native guides allow plenty of time for photography. If a tour doesn't fit

your plans, there is a 17-mile self-guided auto loop that visitors can take. The gravel road passes remarkable desert vistas, which can be photographed from a number of pull-offs. Unguided hiking is, however, not permitted.

Our favorite time to photograph Monument Valley is morning or on overcast days. It takes some effort to take advantage of the infrequent cloud cover. With that in mind, watch the weather closely and try to plan your trip when low-pressure fronts are moving in. This can be a tricky balancing act, because while cloud cover is desirable, full-blown storm systems are not; you don't want to be caught on a dirt road in the Southwest during or after a rainstorm, when the formerly beautiful windblown sand can turn as thick as newly poured concrete.

31. Navajo National Monument

Held sacred by both the Navajo and the Hopi, the ruins at Navajo National Monument represent approximately two thousand years of cultural development. Two ruins of particular interest are accessible and rank among the best preserved in the Southwest.

The first, **Betatakin Ruins (32)**, is first viewed from an overlook along the trail traveling from the visitor center to the floor of Tsegi Canyon, approximately 1,000 feet below. Betatakin is nestled within an immense natural grotto on the canyon wall opposite the overlook. Exquisite images can be taken from here that illustrate how beautifully these ancient villages blend into their natural settings.

Between May and September, rangers conduct tours into the canyon, allowing photographers a more detailed view. Construction on Betatakin probably began around 1250, during a time Native people elected to move from farming villages in the valley to more secure cliff dwellings.

A second, even more remote, village is **Keet Seel (33)**. A hike to this site requires a backcountry permit secured from the visitor center between May and September. The 8-mile hike follows the canyon rim for some distance before dropping steeply into the valley.

The community at Betatakin included 100 residents at its peak, while Keet Seel was home to 150. Both were abandoned around 1300.

Photographing the ruins in Tsegi Canyon requires physical endurance on the part of photographers as well as good technique. Impressive results from these sites will, however, set your collection apart. Shots from the overlook are better on overcast days, when dense canyon shadows are diffused. If the weather does not cooperate, use a graduated neutral-density filter or high dynamic range (HDR) imaging. Both techniques require a tripod, which will also come in handy in the canyon below.

34. Canyon de Chelly National Monument

Just beneath the rugged surface of the Southwest lies a tragic story of Native Americans driven from their ancestral homelands as a result of westward expansion. Nowhere is this story more evident than among the beautiful cliffs of Chinle Wash.

The vast landscape surrounding Canyon de Chelly and Canyon del Muerto, which make up Canyon de Chelly National Monument, was originally occupied by ancient ancestors of the Anasazi. With the introduction of domestic crops, these hunter-gatherers were replaced by farmers. It was during this period that the Anasazi moved into the area's canyons, attracted by seasonal water and rich soil. The farmers built pueblo villages, some located in natural alcoves high on canyon walls. The Navajo, descendants of the Anasazi, lived in the canyons for as far back as the old stories go.

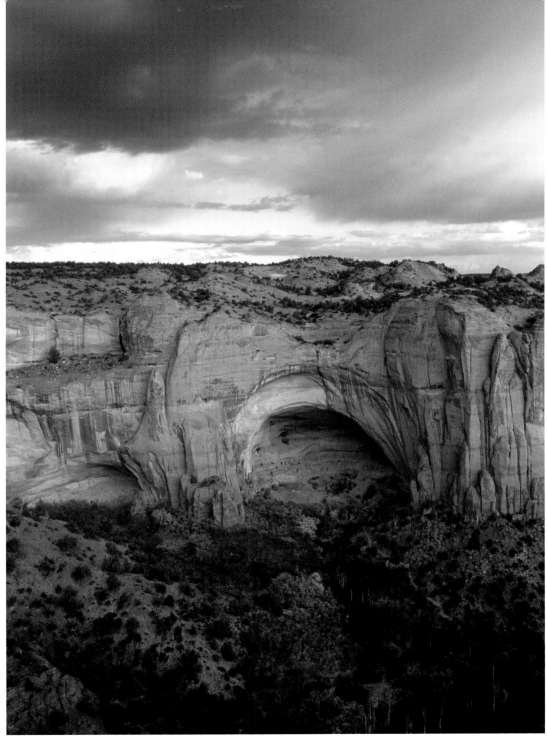

Two spectacular ruin sites are available to the photographer at Navajo National Monument: Betatakin and Keet Seel. Here, Betatakin Ruins is photographed from a trail overlook in the first light of morning, just as the sun cleared the rim of Tsegi Canyon.

As westward expansion reached its peak, pioneer farmers recognized the agricultural value of Navajo land. In one of the cruelest episodes in western history, the simple Native farmers and their families were forced to fight for their lives inside the canyons. Eventually defeated, some three thousand Natives, old and young alike, were marched, from their ancestral home in Canyon de Chelly, 300 miles across a scorching landscape and finally imprisoned at Fort Sumner, New Mexico. Public pressure eventually forced their release, and survivors of the Trail of Tears made their way back to the canyons of Chinle Wash.

At sunrise most mornings you can sit on the rim above the canyon and watch as a bloodred sun washes across sandstone. White House Ruins and Mummy Ruins are among the amazing photographic subjects here, and the challenge to the photographer is to capture them in optimal light. At a certain time early in the morning at White House Ruins, for example, the ruins, the foreground, and the wall above are all in open shade, allowing the contrast between the different elements to remain uniform. Shooting this site under these conditions produces a wonderful result, but it is only possible during a brief window of time each day.

A poignant human history echoes throughout Canyon de Chelly and serves as a constant reminder of the tragic plight of Native peoples in the Southwest. Mummy Ruins is situated at a fair distance across a steep canyon bordering North Rim Drive. This shot was taken with a 400mm lens mounted on a tripod.

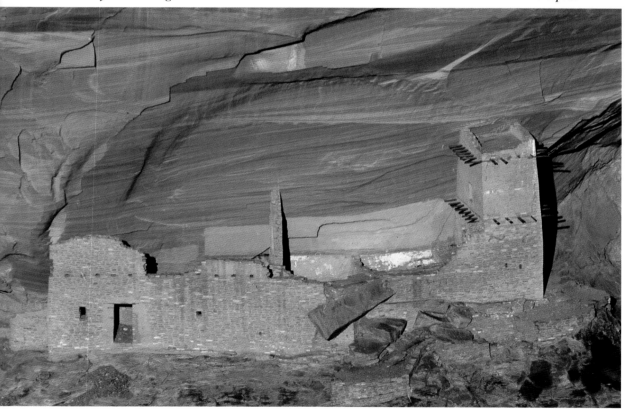

Canyon de Chelly is among our prehistoric sites. Not only does it offer fabulous natural beauty, but the ancient human saga is so clearly seen and felt here.

35. Grand Canyon National Park

Standing on the rim of the Grand Canyon, overlooking evidence of billions of years etched on the canyon's colorful walls, staggers the imagination. Here is a landscape that with each passing moment, each change in the light, transforms itself into something totally new. No place else can a photographer stand in a single spot and expose so many different images. So vast and mysterious is the canyon, it is hard to imagine the impact it had on the ancient people who first happened across it. Through both religion and tradition the old ones were linked closely to the earth and must have wondered as the magnificent colors of the Grand Canyon changed with the light's movement across the landscape; it must have been magical for them. The Zuni and other Native cultures in the Southwest believe it was through the floor of the Grand Canyon that their ancestors emerged into this world.

Given the legends, there must be thousands of ancient sites in the Grand Canyon yet to be explored, and even more meaningful sites connected to the old Zuni stories, which will never be fully understood by modern visitors.

A few ancient sites, however, are available, including **Tusayan Ruins (36)** on the South Rim between Desert View and Grand Canyon Village, and **Walhalla Ruins (37)** on the North Rim near Walhalla Glades Overlook. Each includes the ruins of small pueblos built around the 1100s, home to about 30 canyon dwellers.

A more remote site is located on the north bank of the Colorado River inside the canyon: **Bright Angel Ruins (38)** requires a consider-

The only difficulty in shooting ruin sites such as Tusayan Ruins in the Grand Canyon is keeping your creative eye off the surrounding vistas.

able hike but is well worth the effort. It was first identified by John Wesley Powell during one of his two famous exploratory trips down the Colorado River beginning in 1869.

The Grand Canyon is yet another place a hiker can come across prehistoric sites left off modern canyon maps. The most difficult prob-

lem we encountered while photographing ancient sites in the Grand Canyon was trying to concentrate on technique amid the distraction of all that spectacular scenery.

39. Wupatki National Monument

Spread across 56 square miles of high desert, Wupatki National Monument hosts over two thousand archaeological locations, the result of thousands of years of human occupation. What makes this monument appealing for the photographer is that a number of interesting sites are located along paved roads. The ruins at Wupatki range from single-room field houses to the remarkable one-hundred-room Wupatki Pueblo, complete with ball court, a sign of the Mesoamerican cultural influence.

The sheer longevity of human occupation is another attraction at the Wupatki site. From as far back as eleven thousand years, the faded presence of Paleolithic hunters lingers alongside contemporary Navajo inhabitants who still eke out a living in the area.

The Wupatki ruins are a delight to photograph and include **Lomaki (40)**, **Nalakihu (41)**, **Wukoki (42)**, and the magnificent **Wupatki Pueblo (43)**. Each site includes well-marked trails and impressive vantage points from which to shoot. A few locations feature the sacred San Francisco Peaks as a picturesque backdrop.

Use a tripod here and work for strong composition. Remember the important rule of thirds and the use of detailed foregrounds when photographing ruins. Polarize the sky to add drama.

The ruins are exceptional at sunset and sunrise. One problem you will encounter, how-

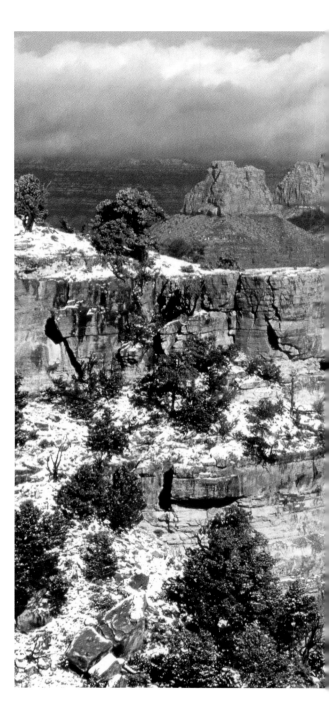

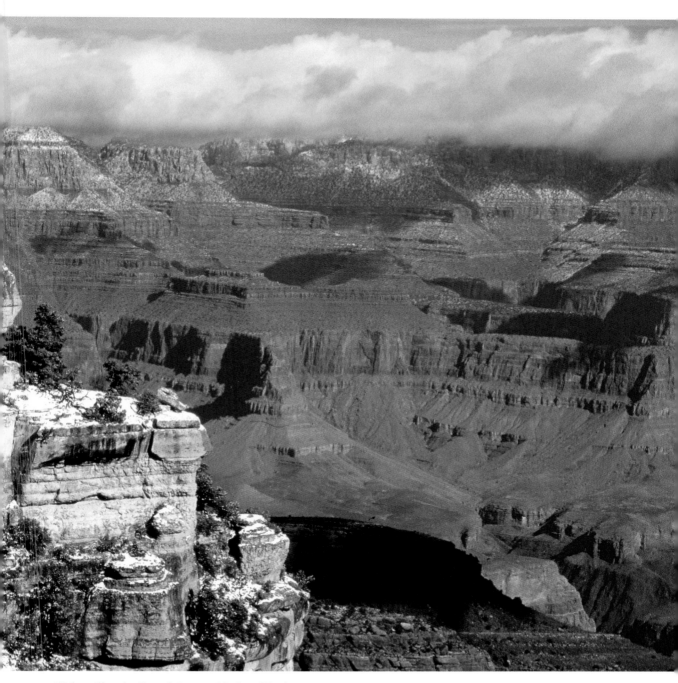

Vishnu Temple, Grand Canyon National Park

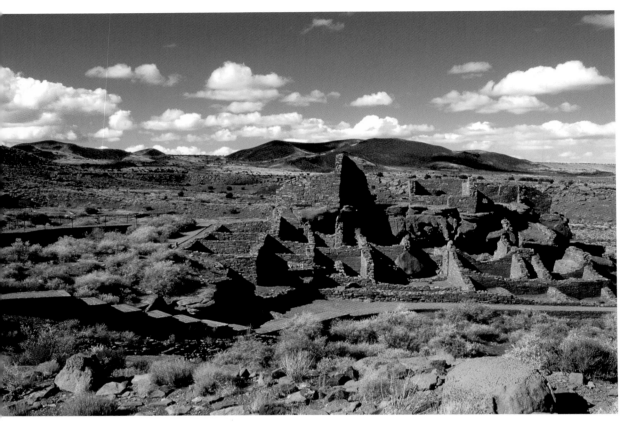

Among the most photographically popular ruins at Wupatki National Monument is the huge Wupatki Pueblo Ruins, complete with ball court. Photographed under warm light, Wupatki Pueblo glows with an amber hue setting it off against a dominant blue sky. There are several great locations from which to photograph the ruins and a host of colorful foregrounds to lead the viewer's eye into the image.

ever, is the limited hours of operation, from 8 AM to 5 PM in summer and 9 AM to 5 PM in winter. National Park managers maintain that increased vandalism at sites like Wupatki have necessitated restricted visitation.

44. Walnut Canyon National Monument

A sister site to Wupatki is Walnut Canyon National Monument, a short drive east from Flagstaff, Arizona. Here Sinagua farmers constructed the pueblo dwellings that are in ruins today. The name *Sinague* is taken from two Spanish words: *sin,* meaning without, and *ague,* meaning water.

In approximately A.D. 600 the Sinague lived in crude pit houses on the canyon rim. They tilled the soil with digging sticks and collected seasonal rain and meltwater to irrigate crops like maize, beans, and squash.

Situated midway between Wupatki and Walnut Canyon rests the huge volcanic cone of Sunset Crater, which undoubtedly had a notable spiritual and cultural impact on the mod-

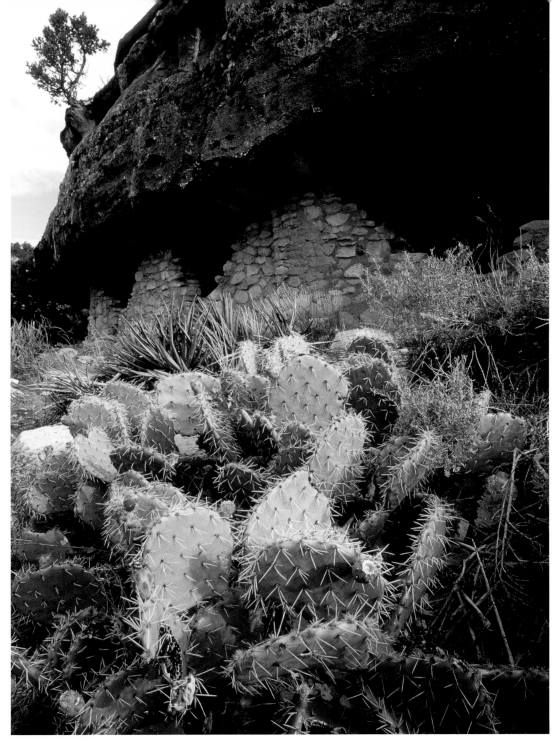

Ancient Sinague farmers built pueblo homes beneath natural alcoves in Walnut Canyon. They grew crops in fields inside the canyon until neighboring Sunset Volcano erupted, forcing them to leave the area. Their descendants returned to a more fertile setting three centuries later.

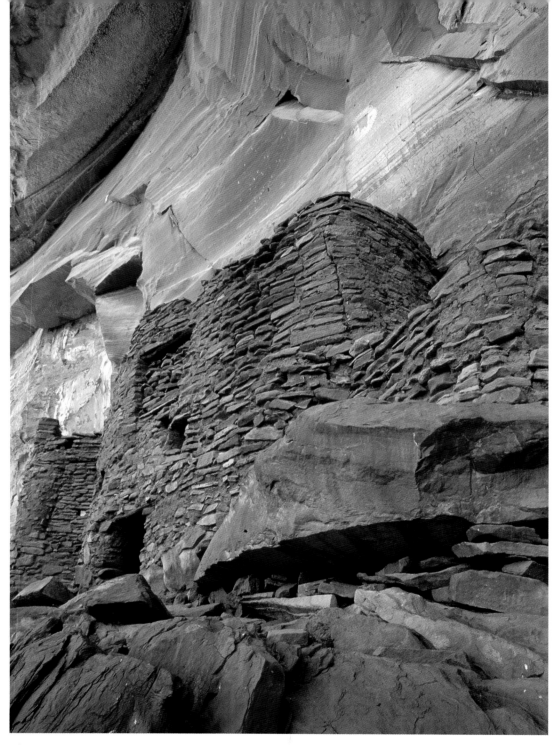

There are a number of ruins and rock-art sites housed within Palatki Cultural Heritage Site and Honanki Ruins. Our favorite is the Grotto, which is built amid rose-colored sandstone. The Grotto is best photographed in open shade to maximize contrast.

est farmers in Walnut Canyon when it violently erupted around A.D. 1064. The surrounding landscape was covered with ash and cinder, forcing the farmers to flee. The Sinague returned years later to a much different, more fertile, homeland on which they flourished for over 150 years. During this time of prosperity the Sinague erected cliff dwellings, which remain today.

A well-maintained trail originates at the visitor center and enters the canyon. Ruins along the trail are located in deep recesses along limestone cliffs. Unless you visit under overcast skies, canyon light includes a mixture of bright, direct light and deep shade inside the ruins. Either graduated neutral-density filters or high dynamic range (HDR) imaging works best. Remember that shaded light contains a heavy blue cast so compensate with filters or white-balance adjustment in your digital.

45. Homol'ovi Ruins State Park

Hopi Indians believe that at one time, their ancestors the Anasazi wandered the rugged Southwest in search of a sacred homeland. During the migration, the old ones built temporary villages like Homol'ovi. They arrived at Homol'ovi sometime around A.D. 750 and lived modestly while farming the fertile floodplain along the Little Colorado River. Eventually the climate changed, forcing the farmers to move on, only to return some three hundred years later. Upon their return they built stone pueblo homes. As they grew more prosperous others joined the Anasazi in Homol'ovi and by A.D. 1200 larger villages were built. The site now known as Homol'ovi I once contained 250 rooms, while Homol'ovi II had as many as 1,000.

Four hundred years later the villages on the Little Colorado were abandoned. Elders among the Hopi believe Homol'ovi and many sites like it were simply a stopping point along the path of migration that ended with the Hopi finally settling atop the Hopi Mesas to the north. If you study the rock art spread throughout the Southwest, sooner or later you will come across a record of this migration, a spiral petroglyph that symbolizes movement of the clan, a powerful message from long ago.

While photographing at Homol'ovi be sure to examine the pottery shards common to the area. Remember, however, that it is illegal to remove anything from a ruin site; there is no better place for artifacts than where they fell as the old ones moved on.

46. Palatki Cultural Heritage Site

The word *Palatki* is from the Hopi language and believed to mean "red house." The name was assigned to the ruins in the Verdi Valley by early archaeologists attracted to the region. Pueblo ruins at Palatki consist of two separate structures occupied between A.D. 1130 and 1200 by the Sinagua. Some experts believe the dwellings might have housed an individual clan, or perhaps a family made up of approximately 30 to 50 members. It is believed that a large shell-like pictograph in the vicinity of one of the ruins could have been the family symbol. Aside from the eastern and western pueblos at the site, it is also renowned for the proliferation and distinctiveness of the rock art in the area.

A trail leads among the ruins and offers a number of good locations from which to photograph. The first ruin is known as **The Grotto (47)** and includes a variety of rock art. From the Grotto the trail leads to **The Bear Alcove (48)**, named for three bear figures etched in the charcoal on the cliff above. The Roasting Pit Alcove is another location and includes rock art that is easily photographed. A second ruin

site, **Honanki (49)**, is located several miles from Palatki.

The Grotto ranks as one of our all-time favorites, and when you see it you'll understand why. The rock and the ruins together make for a spectacular image. Determine which light works best for you by returning to the site several times over the course of the day. Bring along your entire tool chest, including polarizing, warming, and graduated neutral-density filters, and by all means, pack your tripod. We have found that photographing in open shade with a warming filter provides a nice balance at the Grotto.

50. Petrified Forest National Park

Millions of years ago, following the retreat of ancient oceans that once flooded the Southwest, landscapes like that found in Petrified Forest National Park were braided with salt-bearing streams. On the banks grew huge trees, which were often carried off as a result of erosion. Over time the water-soaked trees were buried by silt runoff, halting the natural process of decay for lack of oxygen. Colorful silica-rich minerals eventually replaced wood fiber and the trees crystallized to magnificent quartz.

Both Hopi and Navajo legend speak of the mysterious petrified trees. One myth holds that they were actually the bones of a huge giant, Yietso, slain by Navajo ancestors upon their arrival from other worlds. Alongside the beautiful trees in Petrified Forest National Park are traces of the first people who lived in the area.

For the photographer, this wonderful mixture of natural splendor and human folklore provides a rare opportunity. The human element of the story unfolds in places like **Flattop Village (51)** and **Twin Butte (52)**, where dwellings date back to archaic times. Later dwellings, **Agate House (53)** and **Puerco**

Ruin (54), date to around A.D. 1300. The park also has its own **Newspaper Rock (55)**, reporting the human saga in petroglyphs.

Photographing ruins and rock art here requires the crafty use of lenses ranging from wide angle to telephoto. Regardless of whether you shoot digital or film, the requirement is the same. Smaller point-and-shoot cameras are fine, but do limit the photographer's versatility.

56. Tuzigoot National Monument

At its peak the pueblo at Tuzigoot National Monument probably housed some two hundred members of the Southern Branch of the Sinagua. The name *Tuzigoot* is Apache and means "crooked water." Interestingly, the pueblo structures here follow the natural contour of a 150-foot bluff. Looking at the ruins carefully, you'll notice that they are laid out in a staggered design, lending the impression that they zigzag across the hillside. This dimension adds a sense of intrigue for the photographer, especially during early morning or late evening, when strong sidelight paints shadows across the scene.

During summer, the monument opens at 8 AM and closes at 6 PM. In winter, it closes at 5 PM. This schedule provides a narrow window of opportunity, so when visiting Tuzigoot be sure to get an early start or stay late for the final minutes of sunlight.

Two trails, each about a quarter of a mile, weave through the ruins, which were built in three separate waves. The first started about A.D. 1000 and included 12 rooms near the top of the knoll followed by a second wave adding rooms to the older structure in A.D. 1200. A hundred years later, more came, bringing the total to 77.

Sinagua farmers relied on fertile fields surrounding the knoll. An abundance of wildlife,

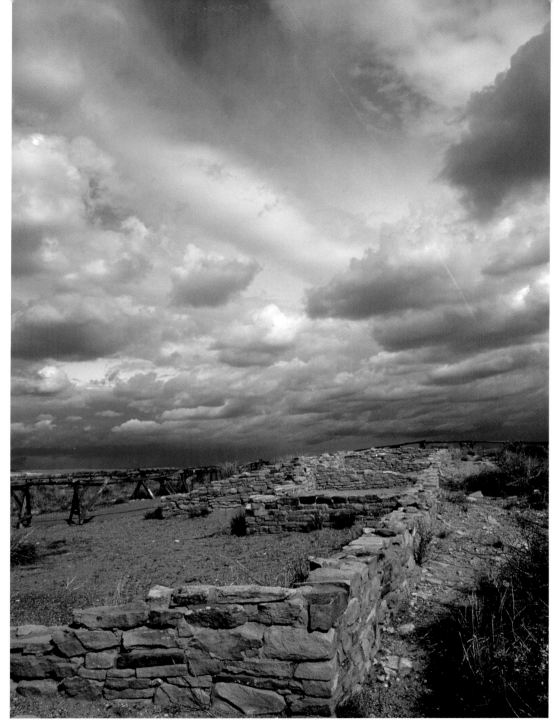

The ancient people who lived in the area of Petrified Forest National Park must have stood in awe of the mysterious petrified wood scattered throughout the area, perhaps imbuing it with sacred meaning and adding to the myths and stories abounding in the area. The ancient dwelling of Puerco Ruin now awaits photographers who can tell its tale.

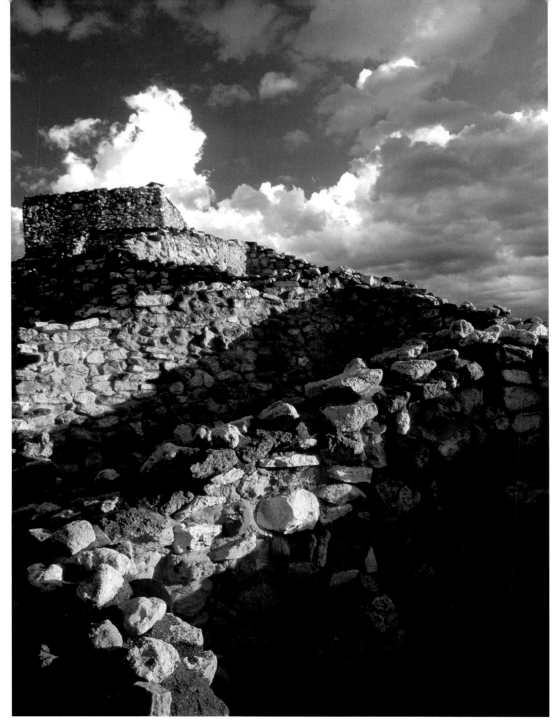

The Southern Branch of the Sinague are responsible for the ruins at Tuzigoot National Monument. Photographers must be patient and wait for the light that best accentuates the scene. We arrived one morning just after a thunderstorm; the light tinted the clouds above while adding an amber glow to the ruins below.

including deer antelope, geese turtles, and ducks were hunted. Like other sites found in the Verde Valley, Tuzagoot stood abandoned by A.D. 1450.

57. V-Bar-V Ranch Petroglyph Site

Southwest rock-art sites reflect their various surroundings, and the V-Bar-V Ranch is no exception. Here the art is on private land, and it is a beautiful natural setting. The scene, the quality of light, and the sheer number and distinctiveness of the petroglyphs make V-Bar-V special.

Drastic climate change in about A.D. 1400 forced Sinague farmers to gather in larger communities to take advantage of available water and abundant manpower. One community, home for as many as one hundred inhabitants, was located atop the ridge overlooking Beaver Creek in the Verde Valley. On the floodplain below, crops were tended, while wild game like rabbits and deer were hunted. On sandstone walls along the creek, Native inhabitants etched some of the sharpest petroglyphs found in the Southwest.

The gallery includes both human and animal images as well as a number of geometric figures of unknown meaning. Created sometime after A.D. 1150, the petroglyphs may have been the work of shamans paying homage to benevolent deities. Another theory suggests that the art served as a signpost for wandering travelers.

V-Bar-V is managed by the United States Forest Service and is open Monday through Friday from 9:30 AM to 4:30 PM, with entrance gates closing at 3:30. We found it best to visit this site in midmorning or late afternoon. Shade is by far the best light to use here and a tripod is necessary. At sites like V-Bar-V we always bracket a stop over and under in one-

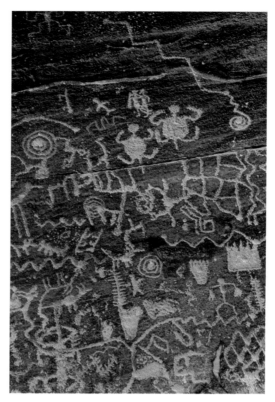

The petroglyphs at V-Bar-V Ranch Petroglyph Site are some of the clearest rock-art images found in the Southwest. Pick the time you photograph here carefully, since the right light is critical for capturing this type of ancient art.

third stop increments to make sure we get what we need.

58. Montezuma Castle National Monument

Ancient life along Beaver Creek followed the same trend of social development as other parts of the Southwest. Hunter-gatherers evolved into farmers with the introduction of domestic crops and eventually built pueblo dwellings like **Montezuma Castle (59)**, located above the floodplain.

Intense direct light as well as the castle's location on the cliffs above Beaver Creek make this site a photographic challenge. We have found that the use of darker foregrounds located in the lush sycamore groves below provide the best images of Montezuma Castle. Try framing the castle with trees either in silhouette or partially lit. Another technique you might try is to use a flash with a diffusing dome to add fill light to the foreground while exposing for the bright background.

A second, smaller, ruin, **Castle A (60)**, is located at the monument a short distance down the trail. Remarkably, Castle A is the remains of what was once a five-story dwelling, heavily damaged by vandals and pothunters in the past.

A separate site, **Montezuma Well (61)**, is located in another part of the monument and includes pueblo ruins tucked among the cliffs overlooking a gigantic spring-fed sinkhole created eons ago. The best way to find Montezuma Well is to ask for directions at the visitor center. A path circles the site and offers a number of great vantage points from which to photograph. It is believed that in ancient times as many as two hundred Sinague lived in the vicinity of Montezuma Well.

One of the best shots of the ruins is a reflection of the pueblo dwellings and cliffs in the crystal-clear water below. The best time to capture this image is early in the morning. Both the well and the castle are open between 8 AM and 5 PM except for Labor Day and Memorial Day, when visitation is extended to 7 PM.

Hanging precariously above Beaver Creek, Montezuma Castle offers an awesome photographic opportunity. This image was shot midmorning and relies on the silhouette of sycamore trees along Beaver Creek to nicely frame the image.

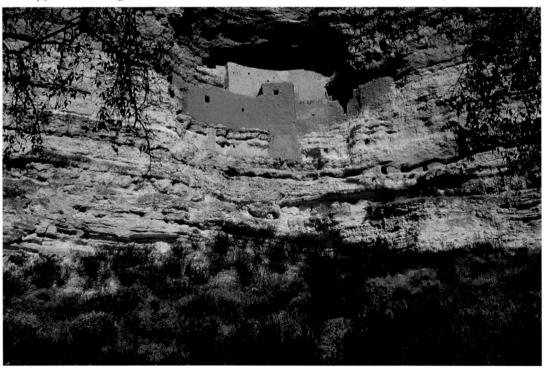

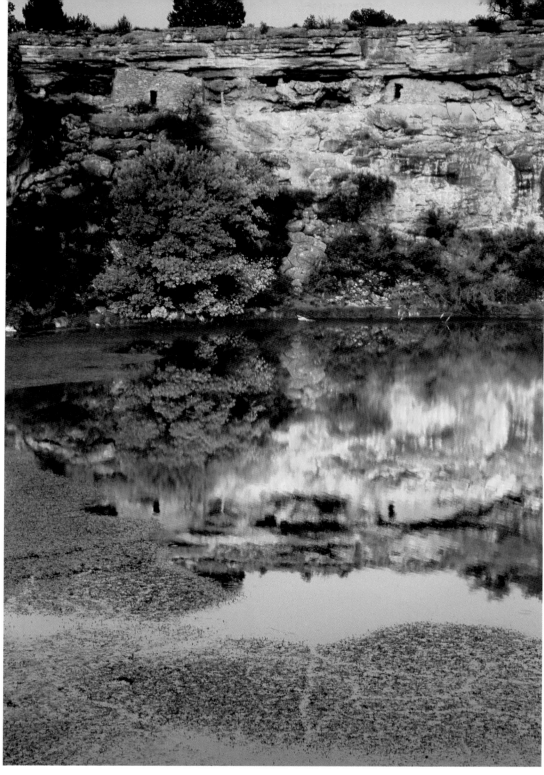

Montezuma Castle ruins reflected in Beaver Creek

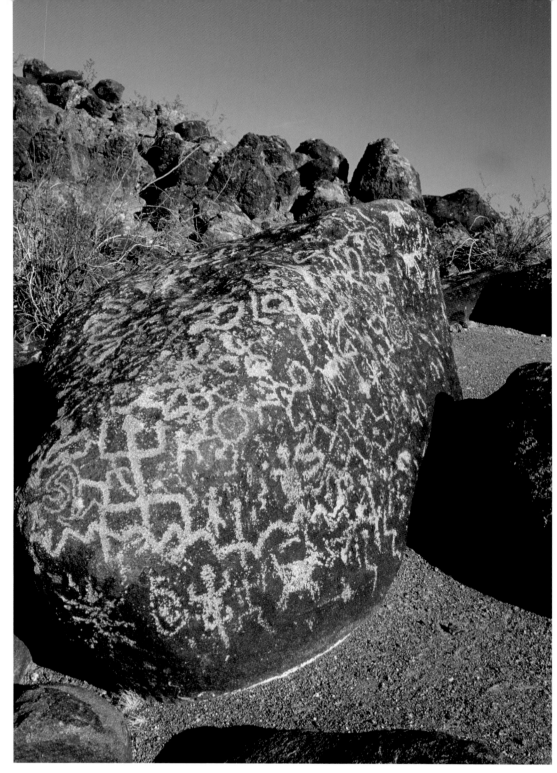

Hohokam artists left the vast array of images at Painted Rocks Petroglyph Site.

62. Painted Rocks Petroglyph Site

We may never completely understand why ancient people selected certain places for rock-art storyboards. Some say the sites are sacred, others believe they were merely stopover spots or physical landmarks for travelers crossing the harsh landscape. A visit to the Painted Rocks will set your mind reeling.

Presently under the protection of the Bureau of Land Management, the site contains approximately seven hundred petroglyphs. The art is believed to be the work of the Hohokam artisans who occupied the Gila Bend region between A.D. 300 and 1450. One thing is clear at Painted Rocks, however: the artisans selected the site for the dark patina covering the large boulders. Once the patina was chipped away by crude instruments, lighter colored rock emerged in stunning contrast.

Remember as you work at Painted Rocks to use a longer lens and isolate individual scenes.

63. Pueblo Grande Museum Archaeological Park

Hohokam farmers who once lived and prospered at Pueblo Grande were by all accounts accomplished irrigators. Their memory, however, is presently buried beneath the huge metropolis of Phoenix. What remains is on display at Pueblo Grande Museum and Archaeological Park. There is much to learn and photograph at the park.

Cathie and I almost never use flash inside a museum, simply because it disrupts other visitors while adding very little to the photograph. Instead, if rules allow, we use available light, slow shutter speed, and a tripod. A word of caution before you haul photographic equipment into any museum: check first to make sure photography is permissible at the site.

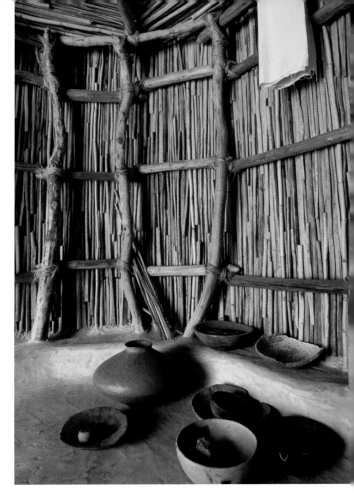

Many interesting ancient artifacts are housed in Southwest museums like Pueblo Grande and make wonderful photographic subjects.

One interesting feature at Pueblo Grande is the massive mound of dirt left by prehistoric farmers. By some accounts the mound rose well above the village and was either used as a ceremonial site or a vantage point from which the ruling class could observe work in surrounding fields.

The Hohokam were accomplished farmers and among the first to utilize extensive irrigation canals originating as far away as the Salt and Gila Rivers.

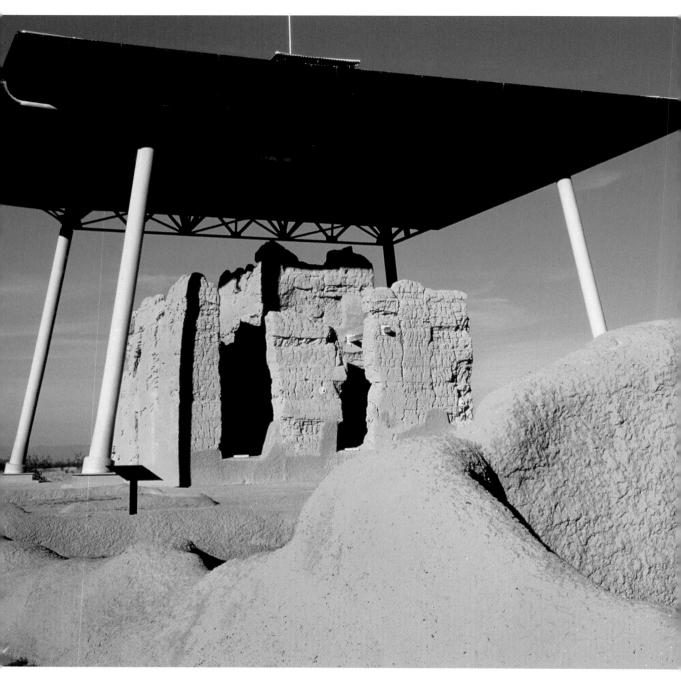

The ruins at Casa Grande are a marvel to the photographer. Here is a place to work with a polarizing filter, capturing the covered ruins against a vivid Arizona Sky.

64. Casa Grande Ruins National Monument

It was the contemporary Papago and Pima Indians who first called the covered ruins at Casa Grande *hottai-ki,* or Great House. Spanish solders in the company of Catholic missionaries followed, and, centuries later, early photographers with unwieldy view cameras and laborious wet plates.

The covered pueblo at Casa Grande Ruins National Monument ranks among the most photographed prehistoric sights in America. Hohokam farmers once occupied the ruins and labored in nearby fields. When time allowed they took advantage of leisure activities and ball games. Like many other large ruin sites scattered throughout Arizona, Casa Grande features the remains of a magnificent ball court, a Mesoamerican influence.

Photographing the Casa Grande ruins can be a challenge simply due to its placement on the landscape. Cathie is partial to shots of high drama and oftentimes uses a polarizing filter to accent deep blue sky while adding high contrast to the overall scene. Her technique works well at Casa Grande, particularly when combined with a strong foreground. Polarizing filters when used at full rotation drain at least two f-stops from exposure. To achieve the result Cathie works for, a maximum depth of field is essential. Even in bright sidelight a polarizing filter can decrease shutter speed well below a 30th of a second, requiring a tripod. As a side note, we find with digital equipment that it is far better to use a tripod than simply increasing ISO to compensate for low or filtered light.

Even though a long line of famous photographers have recorded Casa Grande Ruins, images of the site reflect the distinctive perspectives of individual observers.

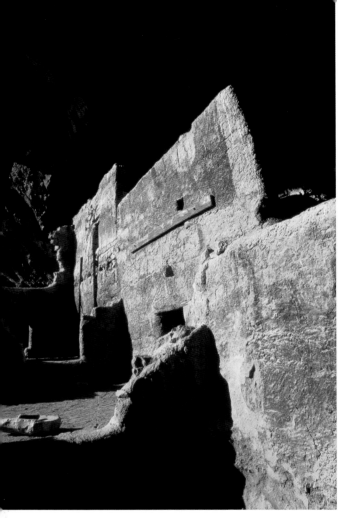

The ruins at Tonto National Monument are well worth the hike to get there. Early morning offers golden light, which will eventually illuminate the ruins.

65. Tonto National Monument

The ruins at Tonto National Monument are located in cave-like alcoves in surrounding mountains. From a distance, the dwellings appear to be protected by the terrain itself. Perhaps that was the purpose of building them there.

Recognizing the cultural importance of the ruins at Tonto, President Theodore Roosevelt set 640 acres aside as a national monument. For the first 30 years under this designation, however, the monument received almost no protection. By 1937 it fell under the management of the National Park Service and was expanded to 1,120 acres.

More than likely it was the availability of water that attracted early farmers to the region. However, for reasons still a mystery, the Hohokam suddenly moved from smaller, randomly scattered villages adjacent to their fields in the valley to more secure pueblo villages high in the hill country. Some believe the move followed a period of social unrest brought on by intense drought in the region. Remarkably, the Hohokam flourished in the area for over three hundred years. But time took its toll on their social traditions as the influence of other cultures began to be felt in these mountain villages. By A.D. 1150 a newly developing culture, the Salado, replaced the Hohokam.

The photographic challenges at Tonto National Monument start with a fair amount of hiking over dry terrain. Another challenge is the time it takes to ensure the light is right, especially on ruins nestled inside deep alcoves. We like to begin our photographic day as early as possible so we are close to either the lower or upper ruins when midmorning light finally reaches inside the alcoves. You are limited at Tonto, because the monument does not open until 8 AM. We like to be the first on the trail so we can take full advantage of early light. Later in the day, we spend time photographing midrange and close-up shots at the ruins.

66. Besh-Ba-Gowah Archaeological Park

The farther the Hohokam migrated from the Salt and Gila Rivers, the more they were influenced by other cultures. They originally settled in subterranean villages around Pinal Creek, a

reliable source of water. In time, however, the Hohokam culture was absorbed by the more modern Salado culture that is believed responsible for the ruins at Besh-Ba-Gowah.

The name Besh-Ba-Gowah is Apache and means "place of metal," referring to the abundant copper indigenous to the area. As you explore the ruins, the influence of Hohokam, Salado, and Apache is evident. For example, buried beneath the pueblo ruins built by the Salado are the pit house dwellings of the Hohokam. More modern features at the site come from the Apache.

For strong sidelight, late afternoon is best. Inside the structures use existing light and long exposures for a pleasing sense of intrigue. Don't forget a tripod, remote release, and warming filter. If possible, mix light sources like shade and direct light or even backlight to create an atmospheric effect.

67. Casa Malpais Archaeological Park

Casa Malpais introduces us to still another ancient culture, the Mogollon, who followed a pattern of social development typical of others in the Southwest. Drawn to tributaries of rivers like the Little Colorado, the Mogollons spread throughout their homeland like ink spilled on a blotter.

As opposed to typical southwestern pueblo ruins made of sandstone, those at Casa Malpais were constructed from a dark stone, a vestige of a tortuous volcanic environment millions of years ago. A guided tour of the ruins just might be the highlight of your Arizona photographic experience. Not only is the setting unique, but so is the human story. The ruins at Casa Malpais are wedded to their surroundings, located as they are beneath a volcanic ridge and featuring natural cracks and fissures as key elements in their design.

Here is an unusual site that will challenge you to employ a full range of photographic techniques. Surrounded by natural vegetation and visually interesting basalt rock, Casa Malpais also tells a rich human story. Give yourself plenty of time to adequately capture this area.

The name Besh-Ba-Gowah is Apache and means "place of metal," denoting the copper-rich area around Globe, Arizona.

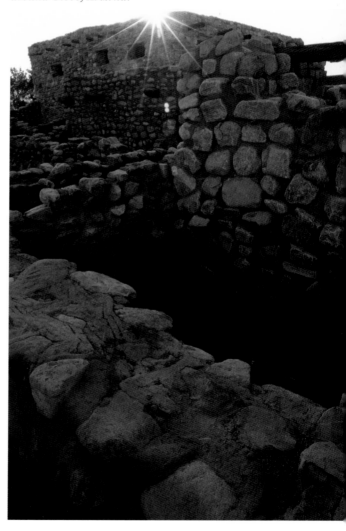

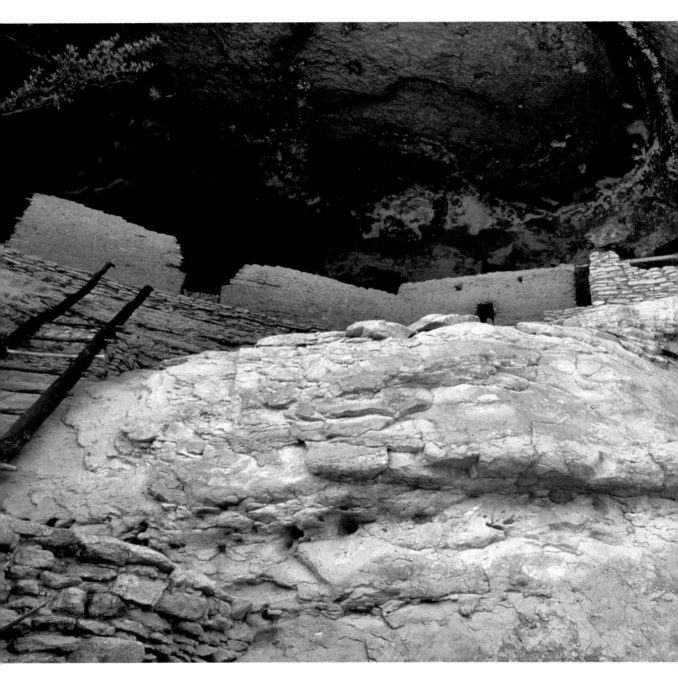

Photographing inside the cave-like ruins at Gila Cliff Dwellings National Monument takes special care. We used a flash with a warm yellow filter for fill light, creating a more pleasant interior.

68. Gila Cliff Dwellings National Monument

The ruins at Gila Cliff Dwellings National Monument are located within caves carved by erosion over millions of years. The dwellings are believed to have been the work of the Mogollon and completed around 1270. A short four decades later they were abandoned. When photographing the ruins, note the black soot marks on the cave ceilings. These are from fires used for cooking and heating.

If you arrive at the park on an overcast day, count yourself lucky and get to work. Strong exterior light will not effect your compositions on such days, giving you a single, balanced light source. For effective interior shots, a slow shutter speed and tripod are necessary. Be sure to warm the scene up. We use flash selectively at this site and primarily as fill light. The flash is diffused and filtered with yellow to lessen impact. Shots outside the ruins are fairly straightforward; however, be careful when metering the light gray stone to compensate for brightness and reflection. We bracket most of our shots at Gila Cliff Dwellings just to make sure.

69. El Morro National Monument

The legendary Zuni people, distant ancestors of the Anasazi, were among the first to encounter Spanish conquistadors in the Southwest. Perhaps in response to that prior threat, the Anasazi built **Atsinna Pueblo (70)** atop the spectacular **El Morro Bluff (71)**. Archaeologists believe the location suggests a siege mentality among the early inhabitants. The se-

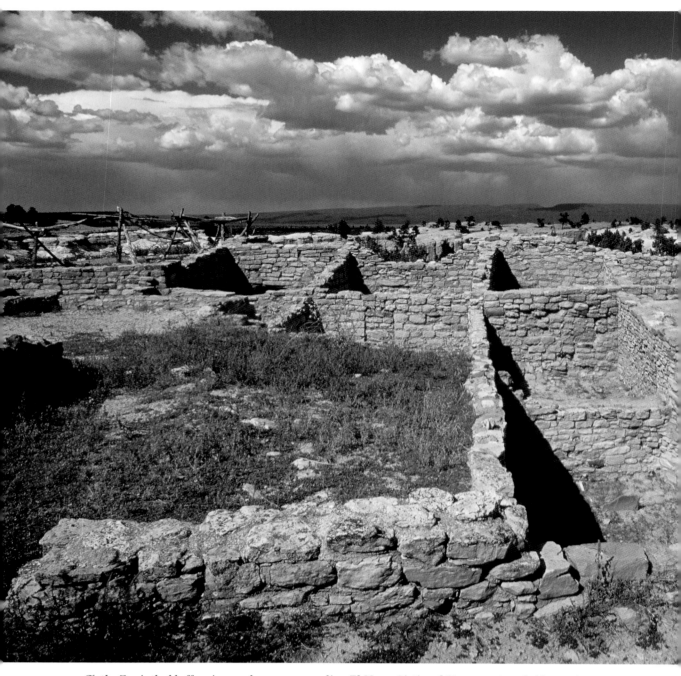

To the Zuni, the bluff, ruins, and area surrounding El Morro National Monument are held sacred. Travelers to the site cannot help but be struck by the enormous achievement of the Native peoples who built the Pueblo high above the desert floor.

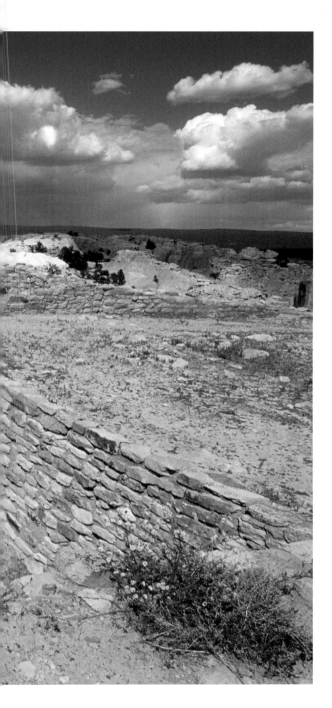

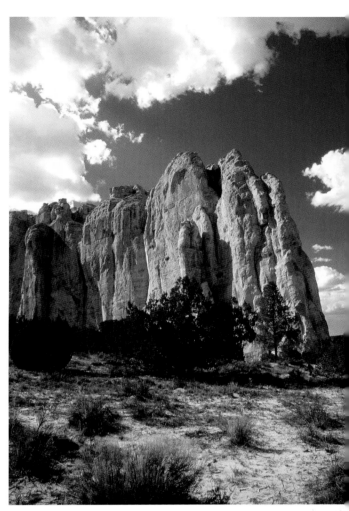

El Morro National Monument

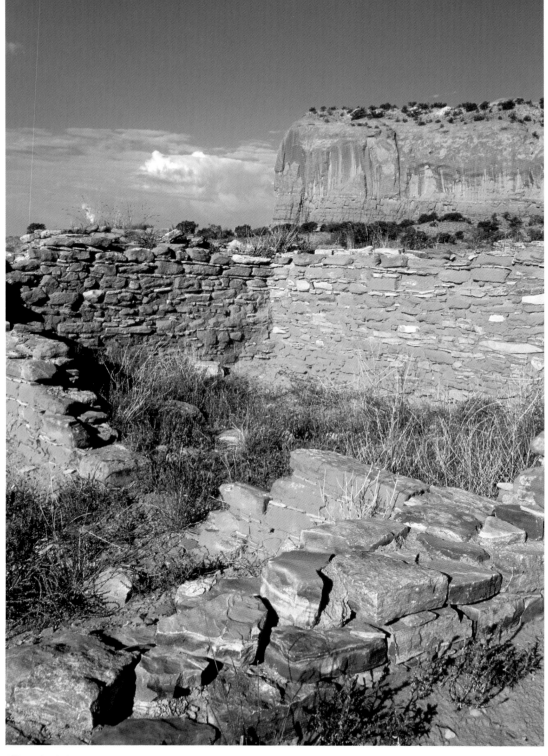

The colorful Casamero Pueblo Ruins is a wonderful photographic subject, complementing the natural surroundings.

curity of the high bluff did not come without hardship, however. Ancient farmers who had once lived in low-lying open areas were now required to carry provisions like food and water in baskets and pottery vessels to their new home high on the bluff.

One of the watering holes used by the farmers is located at the base of the bluff and is well marked. As you photograph the watering hole look for shallow footholds chiseled into the sandstone face. The bluff and watering hole not only chronicle the story of the Anasazi and their Zuni ancestors, they mark the passage of Spanish conquistadors who entered the region in search of the fabled Seven Cities of Gold. One sign of their passage is found on **Inscription Rock (72)**, also located at the base of the bluff.

Photographing Atsinna Pueblo is straightforward; however, we suggest sidelight and a polarizing filter to darken the sky, particularly if clouds are present.

73. Casamero Pueblo Ruins

Here is a little-known ruin set against spectacular sandstone cliffs in the distance. The site is what we know to be typical of small outlier communities associated with Chaco Canyon, situated to the north. Casamero Pueblo once contained 22 rooms and was built from local sandstone slabs bound by generous layers of red clay.

74. Three Rivers Petroglyph Site

Tens of thousands of petroglyphs are inscribed on the dark rocks at Three Rivers Petroglyph site. They are easily photographed from a narrow trail weaving through the rocks. This is another site where ancient artisans selected dark stone to add contrast to their work.

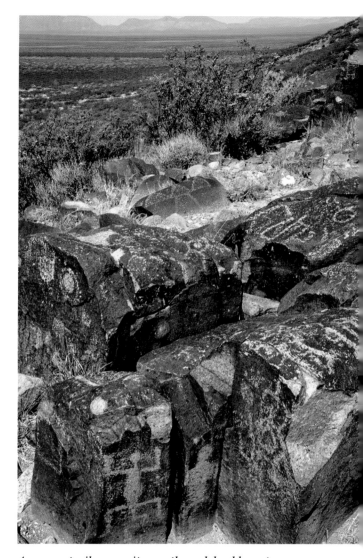

A narrow trail weaves its way through boulders at Three Rivers Petroglyph Site. On the boulders the story of an ancient people unfolds. Photography at the site is a keen experience, unhurried and filled with surprise. What do the petroglyphs mean, why were they left in each particular place, and what message do they have for modern-day observers?

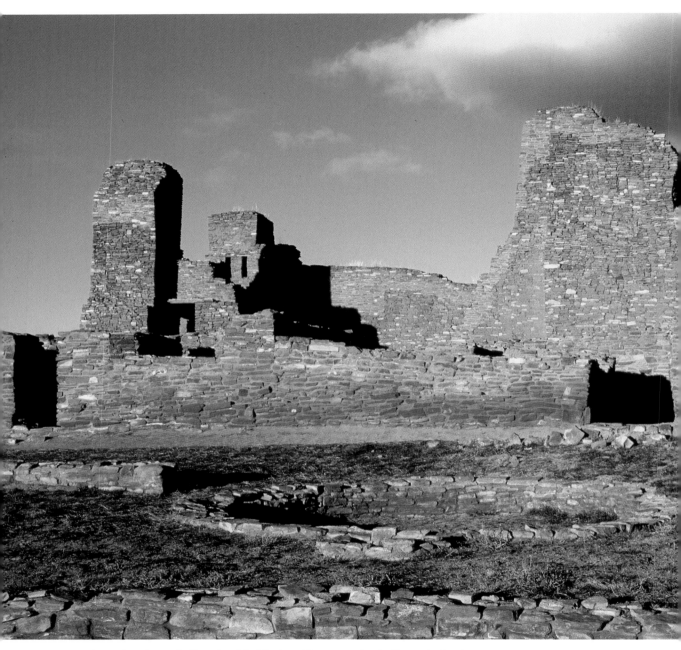

Quarai Ruins at Salinas Pueblo Missions Monument in the Estancia Basin

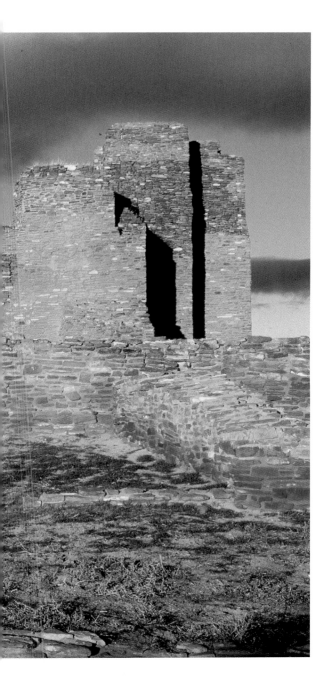

75. Salinas Pueblo Missions National Monument

As early as A.D. 600, modest villages first appeared in the Estancia Basin. In time they included permanent pueblo dwellings. Life in the basin was influenced equally by Mogollon and Anasazi cultures.

By A.D. 1300, drought forced the northern Anasazi to migrate south in search of water. They came from villages as far away as Mesa Verde. The migration prompted growth in the Estancia Basin. Three pueblo villages flourished in the region: **Abo (76)**, built at the base of the Manzano Mountains below Abo Pass, **Quarai (77)**, located in the forest below the Manzanos, and **Gran Quivira (78)**, situated on the southern edge of the Estancia Basin.

By 1598 Spanish invaders had arrived, disrupting Native life in the basin. Thought to be helpless savages, the Natives were forced to sign an "Act of Obedience," effectively making them subjects of the Spanish Crown. The act required the payment of tribute in the form of goods, crops, or slave labor.

Franciscan monks bent on saving souls and extending the Church's influence in the New World accompanied the Spanish army. The Franciscans relied on slave labor to build mission churches at many pueblo villages. By 1660 drought had set in, and hundreds of Natives forced from their fields to build the missions were left without food. Disease outbreaks followed.

A poignant human history awaits the photographer in Estancia Basin. Each of the pueblos and their missions are distinct and set beautifully against natural surroundings.

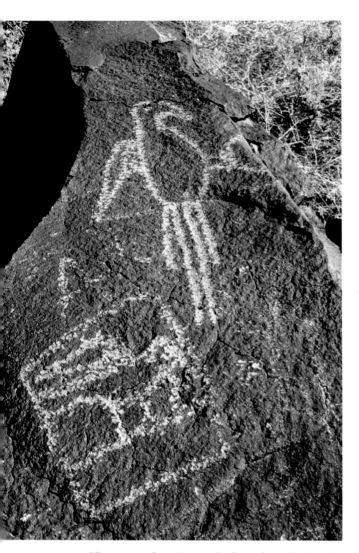

The extent of ancient trade throughout the Southwest is remarkable considering the substantial distances covered. Parrots from Mesoamerica, seashells from the West Coast, and minerals from thousands of miles away are examples of ancient trade goods common to Southwest cultures. Photographing Petroglyph National Monument helps us understand just how well traveled the old ones were.

79. Petroglyph National Monument

The extensive collection of rock art at Petroglyph National Monument dates from prehistoric times to the arrival of Spanish invaders. The petroglyphs are presented on dark volcanic stone and easily photographed.

The range of images here tells the story of human activity in the region, from inscriptions of parrots brought to the Southwest by ancient traders, horses introduced by the Spanish, and religious artifacts associated with Franciscan monks.

Given the dark rock on which the petroglyphs are etched, meter carefully. There is a chance your meter will be thrown off by the severe contrast range of the dark rock and light petroglyphs. This error could mean an entire stop difference.

80. Pecos National Historical Park

In A.D. 1540 the sound of musket fire at the Zuni village of Hawikuh announced the arrival in the American Southwest of Francisco Vásquez de Coronado. Not long after, an invading army arrived in the Pecos River valley, where for over seven hundred years Native farmers had lived peacefully in pueblo villages.

The adventurers were in search of the fabled Seven Cities of Gold, believed hidden somewhere in the southwestern desert. In Pecos, instead of untold riches the Spanish found only simple farmers. Nonetheless, the conquistadors and the Franciscan monks who followed declared the people subjects of the Spanish Crown. Tribute in the form of labor, goods, or crops was required, as was immediate conversion to a strange new religion, Christianity. Under penalty of death, the Natives were no longer allowed to practice their

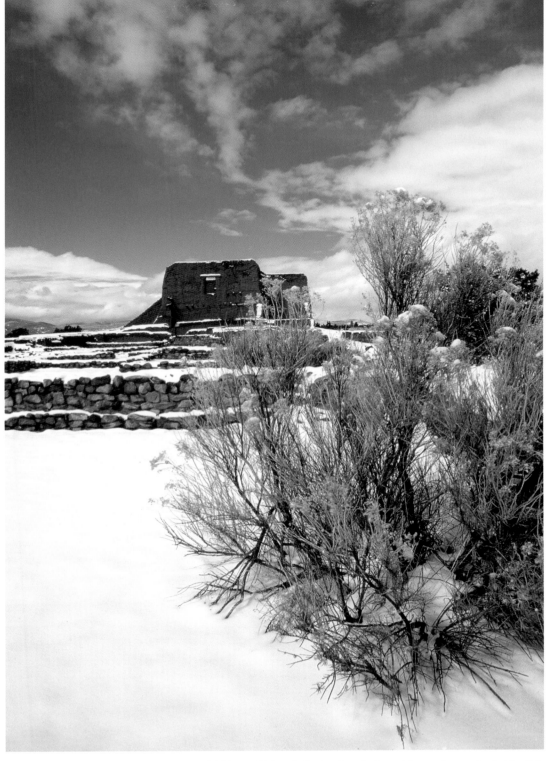

The off-season in Indian Country can yield beautiful and distinctive photographs, as demonstrated by this winter image taken at Pecos National Historical Park.

traditional religion, which had served them from the beginning of time.

Now standing in ruins at Pecos National Monument is a Catholic mission built by Native slaves. In 1680 the people successfully revolted, driving the Spanish from the Southwest. For twelve years the Native people lived free, until the Spanish returned to reclaim the region.

When planning a photographic trip to the Southwest, don't rule out winter, when snow adds a beautiful contrast to the warm regional colors. Monuments are less crowded during the cold-weather months and allow the photographer greater flexibility.

81. Bandelier National Monument

In 1880 the Swiss-born businessman and anthropologist Adolph F. Bandelier boarded a train bound for Santa Fe, New Mexico, and eventually the Indian ruins in Frijoles Canyon. He would be the first to describe this site: "There are some of one, two, and three stories. In most cases the plaster is still in the rooms. Some are walled in; others are mere holes in the rocks."

The efforts of Bandelier and others like him led to federal protection of the ruins in Frijoles Canyon, the oldest dating back to 2010 B.C. It wasn't until the early 1100s that Anasazi inhabitants arrived in the canyon and built stone surface dwellings. As you photograph ruins such as Tyuonyi and Long House at Bandelier, you might find yourself wondering why a people would go to such great efforts to build a community only to suddenly abandon it. Was it drought, invasion, or something else that drove them away? We may never know.

From a technical perspective, Bandelier presents a number of photographic challenges. The intensity of the direct light on the volcanic

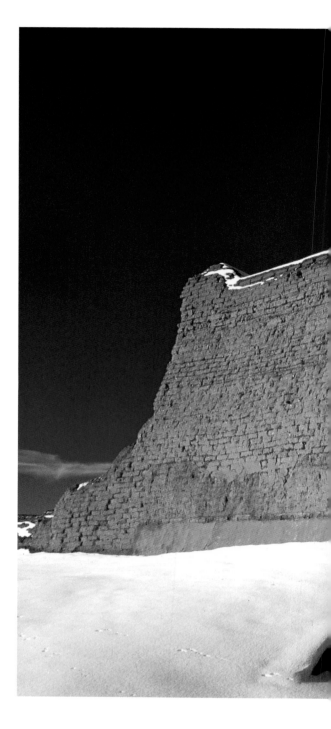

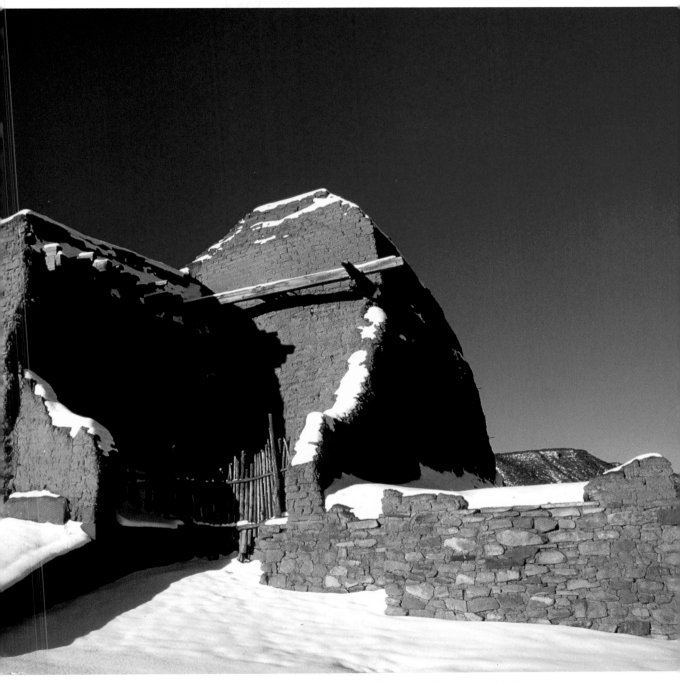

We arrived at Pecos National Historical Park to almost a foot of snow, which lent a mystical quality to the stone mission ruins.

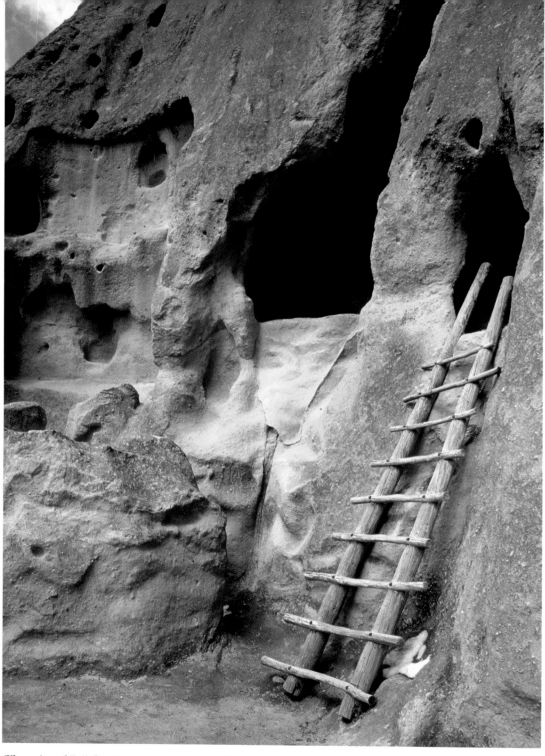

The ruins of Frijoles Canyon, Bandelier National Monument, are situated inside natural caves and thus offer a technical challenge to the well-equipped photographer.

cliffs within which the ruins are located calls for extra care in metering. Because of the brightness, your camera's meter may tend to underexpose by one or even two stops. If you are using a digital camera equipped with a histogram, review it after every shot. Make sure the left edge or white side of the histogram is not blown out and that sufficient detail is recorded in the highlights. We like to bracket in half-stop increments to the dark side using shutter speed as opposed to aperture. If you are using a digital without a histogram, judge your images carefully on the monitor.

Come to Bandelier equipped to solve technical problems. The ruins offer great opportunity but require solid technique.

82. Jemez State Monument

By the time the first Europeans arrived in the Southwest, the Jemez Indians had built a number of pueblo villages like Giusewa high atop surrounding mesas. As many as eight thousand Native inhabitants once lived and farmed in the region. Threat to their way of life arrived with the Spanish conquistador Francisco Vásquez de Coronado in 1541. Fifty years later, Catholic missionary work was well under way. Efforts to force Native peoples to relocate to the vicinity of large missions resulted in rebellion. Tension between the Jemez Indians and the Franciscans escalated, culminating in 1675, when Jemez religious leaders accused of practicing witchcraft were executed in the central plaza at Santa Fe. In 1680 revolt broke out and the Spanish were eventually driven from New Mexico. As violence spread, many colonial missions like the one at Jemez State Monument were destroyed and missionaries put to death.

The story of the Jemez Indians is portrayed vividly at the park. Guide your viewer's eye toward the primary subject for a compelling composition. Search for strong foregrounds

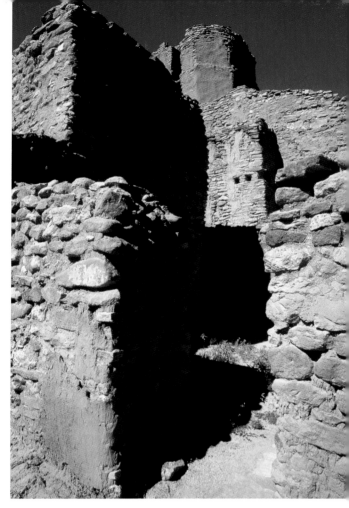

Life changed dramatically for indigenous peoples in the Southwest after the arrival of the Spanish. In the revolt of 1680 many colonial missions like this one were demolished and Franciscan missionaries driven from the region.

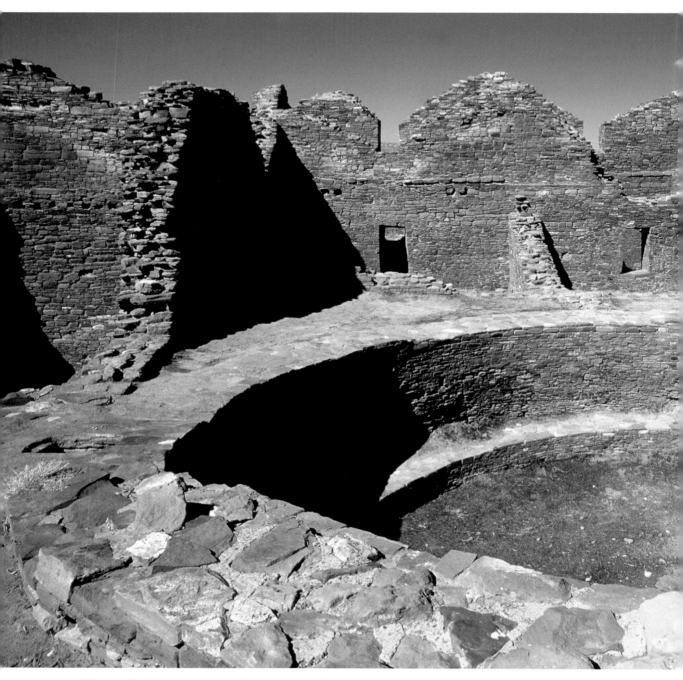

The Pueblo del Arroyo ruin at Chaco Culture National Historical Park awaits the right light and a photographer's eye.

and use graduated neutral-density filters or high dynamic range (HDR) imaging when necessary.

83. Chaco Culture National Historical Park

Of all the wonderful Southwest ruins, those located in Chaco Canyon and Chaco Wash offer special insight into Anasazi life. In a part of the landscape known for extremely dry summers, the Anasazi built a sprawling city complete with several large underground kivas, or ceremonial chambers, an array of multistoried residential dwellings with center malls or courtyards where daily activity took place.

Little is known for sure about the purpose of the massive settlement at Chaco. Some believe it was a trade center serving an extensive region, while others consider the community to have been a religious center. Regardless, Chaco Canyon is certain to capture your photographic imagination.

Plan to spend a couple of days exploring the canyon and its ruins. Here is a site where each hour of the day presents an original image as the angle of the sun inches a path across the canyon. An early-morning hike to the top of the ridge overlooking the ruins offers a magnificent perspective.

Inside the canyon a number of trails lead to the various ruins, including **Una Vida (84)**, **Pueblo del Arroyo (85)**, **Chetro Ketl (86)**, and **Casa Rinconada (87)**. With a little added effort it is possible to take outstanding images from the trails; follow the park's rules when photographing (consult the visitor center).

As you photograph, consider unusual angles and remember the rule of thirds. Interesting compositions as well as effective use of

foregrounds will set your images apart. If clouds grace the sky, work with a polarizer or even graduated neutral-density filters for unique results.

88. Salmon Ruins

The cultural and spiritual influence of Chaco Canyon can still be felt in the smaller outlier communities like Salmon Ruins that radiate out from Chaco for hundreds of miles in all four cardinal directions. A visit here starts at the museum, where the Anasazi story begins to unfold. Beyond, a self-guided tour leads to the ruins of a two-story pueblo that once contained more than 170 rooms. The pueblo exemplifies traditional Anasazi layout, with living quarters facing large open plazas or courtyards. A large keyhole-shaped kiva at Solomon is a worthy photographic subject.

Time your visit carefully. Toward midday, because of the location of the ruins, dark shadows cross the area, adding significant contrast.

89. Aztec Ruins National Monument

Aztec Ruins is a great place to test your photographic skills. You will find the site's Great Kiva perhaps the most challenging to shoot. A tripod is absolutely necessary for long exposures, to compensate for low light, and you may have to wait for other visitors to move through the kiva before you start to work. Early morning, when there are fewer visitors, is the best time to photograph here. For interior shots, remember to warm the scene by altering the color temperature in your digital camera, or add filtration.

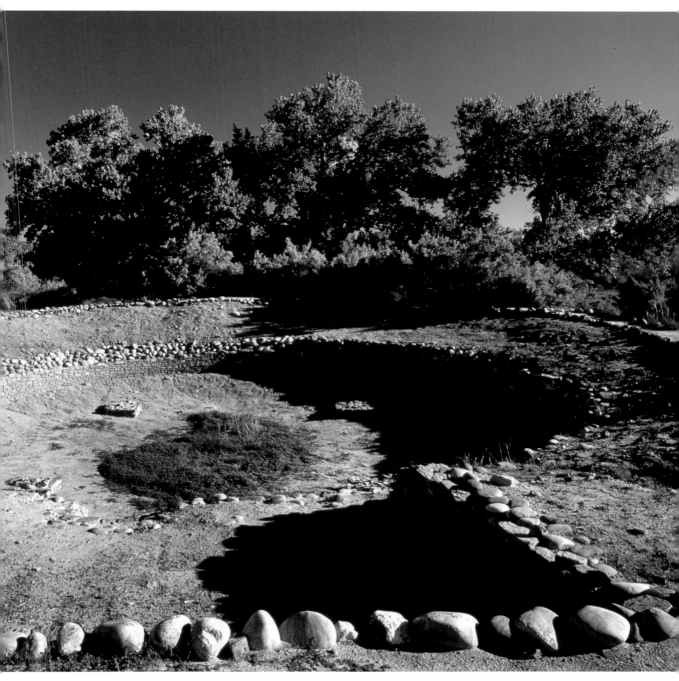

Salmon Village's cultural and spiritual connection to Chaco Canyon can still be felt today at Salmon Ruins. The keyhole-shaped kiva here makes a fascinating photographic subject.

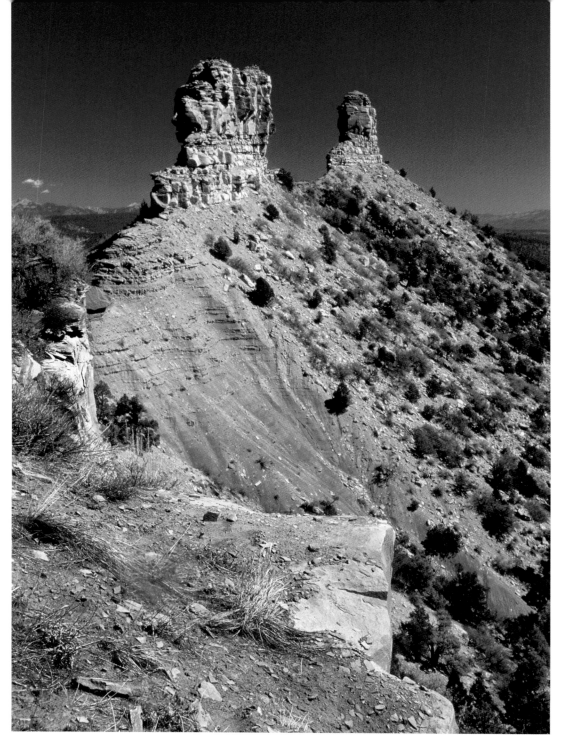

Ancient mysteries abound at Chimney Rock Archaeological Area. We know that the region was once a timber camp supplying stout beams for faraway builders, but did it serve some separate purpose, as a place of celestial observation or a signaling outpost?

IV. Colorado

90. Chimney Rock Archaeological Area

No photographic trip to Indian Country would be complete without a stop at the mysterious Chimney Rock Archaeological Area. The site is named for a pair of nearby spires, **Chimney Rock and Companion Rock (91)**, that set the stage for dramatic images.

Ancient occupancy in the area began in modest dwellings and small farming huts in the Piedra River valley. Around A.D. 1000, people started to migrate from the valley to pueblo dwellings in the hill country above. This site demonstrates a traditional Chacoan influence, and dwellings like the **Great House (92)** are open to visitors. Archaeologists believe the Great House might have served as a guard-house for the twin spires, which may have been used in prehistoric celestial observation. Another theory centers on Chimney Rock's high elevation and potential use for communication by way of a line of signal fires between the spires and Chaco Canyon, hundreds of miles away.

Regardless of the theories surrounding the area, what is known is that it once served as a timber source for the aggressive construction at Chaco Canyon. The industrious Anasazi felled trees in the Chimney Rock area and stockpiled their harvest until snow cover allowed them to slide it to the Piedra River below. The gigantic timbers floated down the Piedra into the San Juan River and eventually reached Salmon Village. From there, porters carried the timbers to Chaco Canyon.

93. Anasazi Heritage Center

One of the most important sites you'll visit in Indian Country is the Anasazi Heritage Center, which includes a complete accounting of the prehistoric inhabitants of the Southwest, supported by an impressive collection of artifacts and displays.

The collection is the result of the United States' largest archaeological effort. The venture began in 1968 to satisfy environmental-impact requirements before damming the Doloras River and filling the massive McPhee Reservoir. The archaeological assessment identified as many as 1,600 primitive sites, with 120 extensively studied. The work resulted in a bonanza of relics presently housed and displayed at the center.

It is permissible to photograph inside the center, but make sure you are aware of the rules before hauling in your equipment. This is the place to get great close-ups of ancient artifacts. Before you begin, however, take close note of the available light and compensate accordingly either with filtration or white-balance adjustment. If you are not sure of the light source, ask the expert staff. We have found a longer lens such as an 80–200mm zoom helpful in isolating individual objects. Give yourself plenty of time to set up your shots, and be mindful of having to work around other visitors.

94. Lowry Pueblo Ruins

Looking across the Great Sage Plains, it is hard to conceive that just a few feet below the surface, buried by centuries of windblown sand, is a completely different landscape. The area is home to a multitude of unexcavated Anasazi ruins. The Great Sage Plains may very well represent the highest concentration of unearthed archaeological sites in the United States. It is fitting that the area goes by the name Trail of the Ancients National Monument.

Lowry Pueblo, excavated in 1930, is included within the monument. The Lowery ruins were built after A.D. 1060 and feature a **Great Kiva (95)** measuring 47 feet in diameter. The kiva's roof was once spanned by four massive timbers secured from local forests.

Late one evening my luck suddenly ran high at the Great Kiva. I had already put my equipment away for the night and sat watching as large, black thunderheads cruised across the distant sky like an invading armada. Every few minutes a jagged bolt of lightning lit the landscape, and the urge finally got to me. I set up a camera on the edge of the Great Kiva just as the storm arrived over the ruins. In the midst of the lightning, I raced back to my truck to get a pair of flash units linked by a remote slave unit. The rest is history.

Both flashes were set on manual to deliver an even ratio of light, just enough to add a mysterious quality to the image. Sufficient depth of field was an important consideration, so the aperture remained as small as possible. After I'd taken a few shots, the black clouds burst and the rain sent me running for cover.

Incidentally, we don't recommend shooting during thunderstorms, but every now and again we are all nudged a little by fate.

All photographers have a unique sense of vision. The days we spent at Lowry Ruins were among our most personally rewarding. This shot of the Great Kiva during a thunderstorm represents our thrilling engagement with the dramatic landscape of the Southwest.

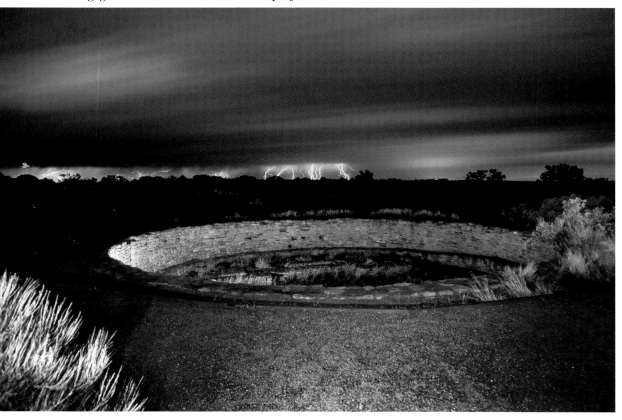

96. Ute Mountain Tribal Park

Spread throughout Johnson and Lion Canyons, the ruins of Anasazi farmers are today found in one of the Southwest's most original sites. Each pueblo-style ruin is nestled securely beneath sandstone formations. Tree-ring data from timbers within the canyons date construction of the Anasazi cliff dwellings to sometime after A.D. 1130, following the abandonment of homes located on the canyon floor. The ruins at Ute Mountain Tribal Park were first discovered by the Wetherill brothers in the later part of the 19th century, and stabilized by the National Park Service in the 1970s. Located nearby Mesa Verde, it is believed trade between the two areas was ongoing and fruitful until both settlements were suddenly abandoned for unknown reasons.

Ute guides, though they claim no ancestral connection to the Anasazi, serve as excellent interpreters and are willing to make special provisions for photographers. A host of ruins make up the site. The canyon location can make photography a challenge, however, as bright light and shadows mix throughout the day. The Ute provide either half- or full-day tours; we found a full day to be best, ensuring you'll get the most suitable light on significant ruins like Tree House, Lion House, and others along the route.

A tripod can be heavy to carry in, but if you must work in canyon shade, it becomes a real necessity. One piece of equipment you don't want to leave behind is a warming filter, which will help should shadow become a problem.

As you work among the ruins at the Ute Mountain site, the presence of the old ones remains. It is believed that as many as 250 Anasazi once thrived in the canyons now protected by the Ute Indians. Call ahead to make arrangements, and mention your interest in photographing the ruins.

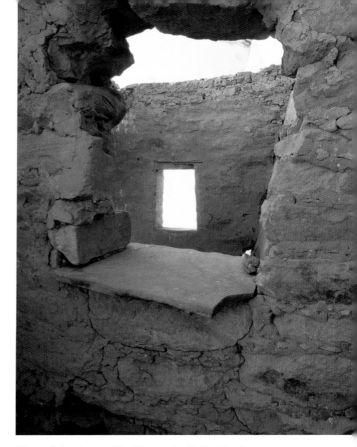

Most of the sites at Ute Mountain Tribal Park appear much as they did when first recorded in the later part of the 19th century. The Ute Indians claim no direct connection to the ancient Anasazi, but they manage the park with reverence for Native American culture both past and present.

97. Mesa Verde National Park

We purposely left Mesa Verde National Park for last, simply because it is among the most impressive sites in the Southwest. For Cathie and me, Mesa Verde represents the culmination of our efforts to photograph the rock art and ruins of the Southwest. The park was dedicated in 1978 as a World Heritage Site by the United Nations Educational, Scientific, and Cultural Organization (UNESCO), a fitting and prestigious accolade.

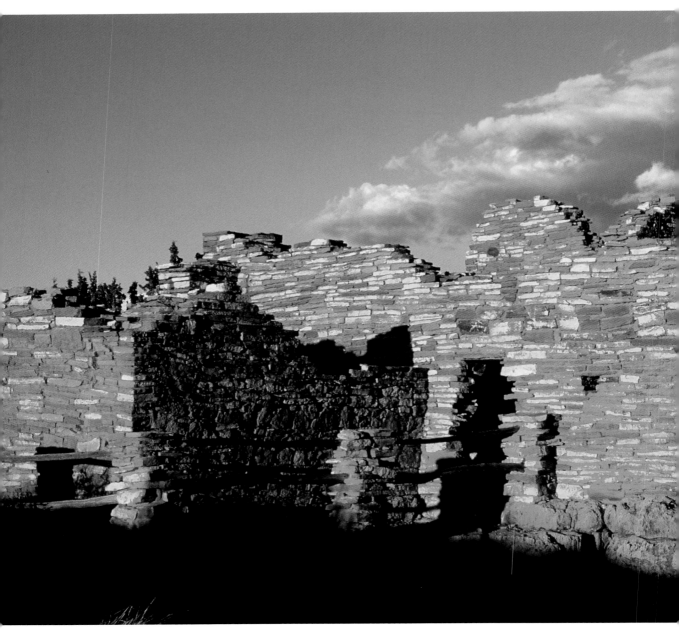

The Southwest is famous for its quality of light, perhaps especially the warmth imparted at dawn and dusk, as demonstrated in this late-afternoon shot of Lomaki Pueblo at Mesa Verde National Park.

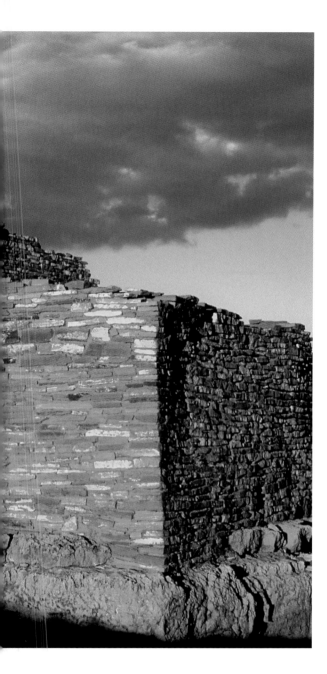

Begin your photographic work at Mesa Verde by capturing the famed ruins of **Cliff Palace (98)**, **Balcony House (99)**, or **Spruce Tree House (100)** from pull-overs along Ruins Road. You will soon discover why this site ranks among the best. Shooting from the canyon rim requires a longer lens, 100mm to perhaps 300 or 400mm depending on the detail you want to include. For our work, which very often calls for extended depth of field and maximum sharpness, we use a tripod, electronic or cable release, and mirror lockup. This takes some time to set up, but when you view your final images, you'll appreciate the difference.

Because the Mesa Verde ruins are located inside the canyon, it's important to time your shots to avoid a mixture of strong highlight and closed shade. For canyon shots under overcast skies, use an 81A or 81B warming filter, even on your digital camera.

For midrange and close-up shots you will have to take a guided tour into the canyon. In order to make the most of the tour, learn to shoot various angles quickly and without holding up other sightseers or including them in your shots. If you spend a little time with the staff at the visitor center you might acquire some suggestions for in-canyon photography.

Shots in the canyon should include detailed foregrounds emphasizing detail and structure. On all your shots be careful to monitor the effect of heavy shadows and bright highlights. Meter for the highlights if all else fails. If you shoot digital, use the camera's histogram to evaluate each shot and never let highlights or shadows blow out.

Pueblo ruins at Mesa Verde National Park, like Cliff Palace and Spruce House, mark the final phase of the prehistoric story of the Anasazi. Well-preserved displays found along the **Wetherill Mesa Road (101)** chronicle other eras in cultural advancement in Indian Country.

Conclusion

Ansel Adams once wrote of photographing the Southwest, "It is all very beautiful and magical here—a quality which cannot be described. You have to live it and breathe it, let the sun bake into you. The skies and the lands are so enormous, and the detail so precise and exquisite that wherever you are you are isolated in a glowing world between the macro and the micro, where everything is sidewise under you and over you, and the clocks stopped long ago."

Over the four decades in which we have chased light, Cathie and I have been blessed to visit and photograph some of the most spectacular landscapes on earth. We walked away indelibly touched by what they brought us and taught us, and the American Southwest, with all its beauty and legend, for us remains very much a project unfinished. We know we shall soon return and take up where we left off. When we do, we hope to find you hard at work, camera in hand, dust on your boots, and a wide smile on your face. See you in Indian Country!

Capitol Reef National Park